Jenny Ross

THE BEAVERBROOK ART GALLERY COLLECTION

SELECTED WORKS

THE BEAVERBROOK ART GALLERY COLLECTION

SELECTED WORKS

IAN G. LUMSDEN

CURTIS JOSEPH COLLINS

LAURIE GLENN

THE BEAVERBROOK ART GALLERY

This publication illustrates a selection of works from the Gallery's permanent collection. It cannot be guaranteed that an object illustrated here will be on display.

Collections management by Rachel Brodie.
Photographic reproductions provided by *The Daily Gleaner*, Geoffrey Gammon, George Georgakakos, Kelly LeBlanc, Stephen MacGillivray, Adda Mihailescu, Keith Minchin, Mira Godard Gallery.
Publication design by Julie Scriver, Goose Lane Editions.
Colour separations by Maritime Digital Colour (Moncton).
Printed and bound in Canada by Transcontinental.
10 9 8 7 6 5 4 3 2 1

Canadian Cataloguing in Publication Data

Beaverbrook Art Gallery
 The Beaverbrook Art Gallery collection: selected works

Issued also in French under title: La collection de la Galerie d'art Beaverbrook.
Includes index.
ISBN 0-920674-47-X

1. Art, Canadian. 2. Art. 3. Art – New Brunswick – Fredericton.
4. Beaverbrook Art Gallery.
I. Lumsden, Ian G. II. Collins, Curtis J., 1962-
III. Glenn, Laurie Arlene, 1957- IV. Title.

N910.F7A8 2000 708.11'5515 C00-901603-1

The Beaverbrook Art Gallery
703 Queen Street
Fredericton, New Brunswick
CANADA E3B 5A6
www.beaverbrookartgallery.org

CONTENTS

ACKNOWLEDGEMENTS

Our appreciation is extended to The Beaverbrook Canadian Foundation who is the principal sponsor of this publication.

The Beaverbrook Art Gallery also acknowledges the generous contributions of the following donors to this publication:

The Estate of Elizabeth Baker
Mr. & Mrs. J. W. (Bud) Bird
Mr. & Mrs. Arnold Budovitch
Mrs. Mendel Chernin
Mr. & Mrs. Richard Clark
Mr. & Mrs. Arthur Clarke
Dr. & Mrs. G. R. Clayden
Drs. Thomas J. & Ann Condon
Mr. & Mrs. Kenneth Dauphinee
Mr. Murray G. K. Davidson
Julian & Sherron Dickson
Dr. & Mrs. C. Fred Everett
Mr. & Mrs. John Flemer
Mrs. Patricia Forbes
Mr. & Mrs. Rowland C. Frazee
Mr. & Mrs. David Hay
Mr. & Mrs. Edward S. Heney
Mrs. Howard B. Hodgson*
Mary Dingee Jacobs and Paul Jacobs
Dr. Marie Jewett

Mr. & Mrs. William Jones
Dr. Peter Kepros
Mrs. J. J. Kimm
Mr. Ralph Kirkbride
Bob and Marg Leonard
Mr. & Mrs. Ian G. Lumsden**
Mr. H. Harrison McCain, C.C.
Mr. Mark McCain
Mrs. Faye Medjuck
Dr. Mary Ella Milham
Dr. & Mrs. A. B. Mitchell
Dr. & Mrs. Donald Morgan
Ms. Patricia Morrison
Mr. & Mrs. Gerry Mulder
Dr. & Mrs. Robert Neill
Edith & Jamie Reid
Mrs. Elizabeth Taylor Rossinger
Mr. G. Stephenson Wheatley
Mr. & Mrs. John Williamson

*Donation of Mrs. Howard B. Hodgson in memory of her husband, Dr. Howard B. Hodgson
** Donation in memory of Dr. Howard B. Hodgson

The publication of this handbook was the unanimous choice of all of the Gallery's stakeholders for our fortieth anniversary project. As staff and volunteers have long identified the need for a concise guide to our internationally recognized collection, the enthusiasm and support we encountered during this past year was not surprising, though it was certainly gratifying and appreciated.

As with so many efforts at the Beaverbrook Art Gallery, the task was realized through the cooperation and support of our benefactors, our membership and our staff. No sooner was the project announced than the Beaverbrook Canadian Foundation generously contributed half the funding to ensure the success of the initiative. The Foundation's unfailing support has spanned our forty-year history and has been the catalyst for much of our success. Another significant portion of the funding was provided by a contribution from the Elizabeth Baker Fund, enabling the Gallery to direct the income from this former Life Member's generous bequest to a project that would have been dear to her heart, both as an educator in this province and a docent here at the Gallery.

Our Life Members and general membership supported the project with gifts and pledges that exceeded our original goal and enabled the Gallery to pursue the project with confidence.

The staff responded to this support with great enthusiasm and has produced a remarkable book that will enable all who visit and know our institution to share their enthusiasm with others through dissemination of the book as gifts and to relive their experience at the Gallery by reading this insightful guide.

I have always enjoyed the cooperative spirit of those who believe in the Beaverbrook Art Gallery, and I will never fail to be impressed by the level of support the institution enjoys.

Once again, I want to thank our benefactors, Board of Governors, membership and staff for their outstanding contributions, and I want to recognize Goose Lane Editions for their tireless and professional commitment to this initiative.

JUDITH CHERNIN BUDOVITCH
Chairperson
Board of Governors
The Beaverbrook Art Gallery

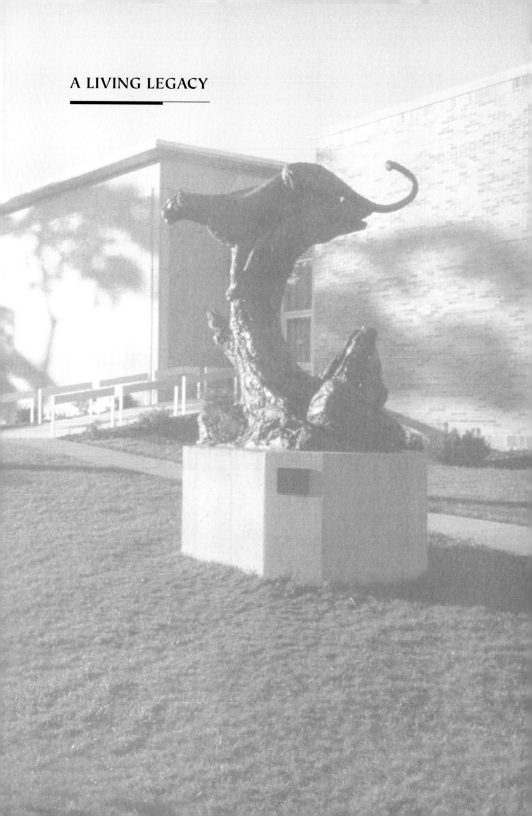

A LIVING LEGACY

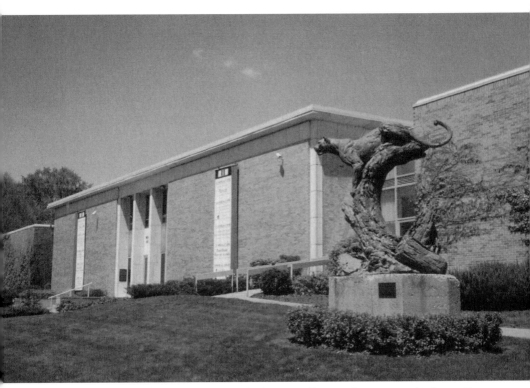

The Beaverbrook Art Gallery, 2000, with *The Leopard* by Jonathan Kenworthy (b. 1943)

Ian G. Lumsden

It may be that I am recalled chiefly as the builder and founder of an art gallery. The labour of age may prove more lasting than the strident achievements of youth or the aggressive toil of middle life. . . . The eyes of youth, falling upon these walls, may draw from them an impulse to create and emulate.

Excerpt from Lord Beaverbrook's address on
the occasion of the official opening of the
Beaverbrook Art Gallery, 16 September 1959.

Although it would be an overstatement to say that all of Lord Beaverbrook's life was a dress rehearsal for the culminating event of his career, namely the opening of the Beaverbrook Art Gallery, the period of gestation did go back four decades. In 1916 he and fellow press baron Lord Rothermere decided to build an art collection for the people of Canada through the Canadian War Memorials Fund. Like the collection he would build for the people of New Brunswick forty years later, this collection comprised works by British and Canadian artists reflective of both our colonial past and contemporary times. However, unlike the Beaverbrook Art Gallery's collection, the Canadian War Memorials collection never had a gallery expressly built to house it, because Mackenzie King, Prime Minister at the time, defaulted on his promise to provide one.

Unlike many philanthropists who build art galleries to house collections assembled to enhance their own reputations, Beaverbrook built his collection, which originally constituted three hundred works

of art, for the youth of New Brunswick. He realized that his home province was in need of a world-class art gallery when he relocated to Britain in 1910. Having become a millionaire in Canada through various business mergers, including the founding of the Canada Cement Company, Beaverbrook decided to try his luck in Britain. He ran successfully as the Conservative candidate for Ashton-under-Lyne in 1910, while at the same time starting to assemble his newspaper empire, which eventually comprised the *Daily Express*, *Sunday Express* and *Evening Standard* and functioned as the propaganda engine for his political career. As a house guest at the country seats of such friends as Diana Cooper, Sybil Colefax and Emerald Cunard, whose "long galleries" housed generations of family portraits and other commissioned works, Beaverbrook became aware of the impoverishment of his early environment with respect to the visual arts. Although the Presbyterian manse at Newcastle, New Brunswick, had afforded the young Max Aitken access to a small library, works of art were definitely alien to that community. Beaverbrook referred to the New Brunswick of his youth as "a constricting environment for a boy of imagination, ambition and vision."

Instead of rushing out to acquire an important collection of pictures in order to enhance his self-image, Beaverbrook elected to become a patron of such writers as H.G. Wells, William Butler Yeats and Arnold Bennett and painters such as William Orpen and Walter Richard Sickert. The enduring bond he created with these artists was much more empowering that any assemblage of artifacts could ever be.

As the proprietor of Beaverbrook Newspapers, a major chain, Beaverbrook occupied one of the most influential positions in the Western world. Yet, according to an article by Michael Wardell, former publisher of the Fredericton *Daily Gleaner* and a confidant of Beaverbrook, his motivation in all aspects of his patronage was to help "young men and women to assert themselves and claim their place in

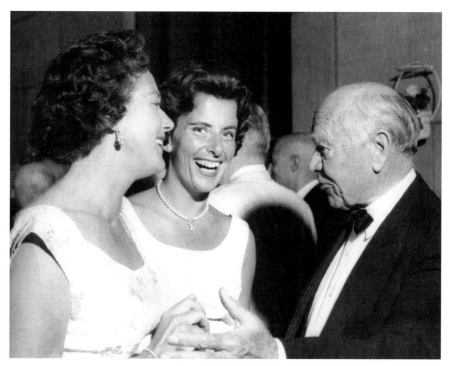

Kay McGuire (left), Lucinda (Vaughan) Flemer and
Lord Beaverbrook at Lord Beaverbrook's Dinner, 1959

the sun." Wardell wrote, "He has always seemed to see youth as op-
pressed and confined under a crust of privilege, inertia and intolerance
created by the established order of old men, the young writhing and
wriggling to get out and claim their dues; and Beaverbrook has been
ever ready to crack a bit of the crust off with a zeal that has occasionally
attracted the criticism of the elderly and orthodox."

Whether it was the establishment of the Canadian War Memorials
Fund or the construction of the Beaverbrook Art Gallery, Beaverbrook's
patronage was always directed toward the facilitation of the advance-
ment of the young.

The construction of the Beaverbrook Art Gallery was a saga of shifting locales, replaced architects and fluctuating mandates. Coordinating operations for Beaverbrook was the deposed deputy director of the Tate Gallery, Le Roux Smith Le Roux. An urbane South African, Le Roux was employed by Beaverbrook and the London *Evening Standard* in June 1954 after his attempt to wrest power from Sir John Rothenstein, the director of the Tate Gallery, failed. The *Standard* and Graham Sutherland, one of the Tate trustees, had supported Le Roux in the attempted palace coup. Beaverbrook first engaged Le Roux as an arts reporter for the *Standard,* but Le Roux soon became a consultant for the art collection that Beaverbrook had decided to build for the people of New Brunswick.

Beaverbrook's original plan was to build the gallery in Saint John, but he also considered Newcastle and Mount Allison University in Sackville before finally settling upon Fredericton. As Chancellor of the University of New Brunswick, he wanted to see a Fine Arts Program develop at the university that was equal to the one at Mount Allison, with the collection functioning as a teaching resource.

Le Roux was given the task of assisting in the selection of an architect. He was assisted by Margaret Ince, Beaverbrook's secretary at the London *Daily Express*. Mrs. Ince suggested that they hold "a competition for architects amongst young men," but the competition did not produce a successful candidate. Le Roux requested the names of examples of "well-planned small art galleries" from Francis Henry Taylor, Director of the Metropolitan Museum of Art, and elicited possible prototypes in the "new Art Gallery, Clearwater, Florida, the Walker Art Centre, Minneapolis, and two new galleries in Texas." At Beaverbrook's behest Le Roux visited the Lady Lever Art Gallery, Port Sunlight (near Liverpool) in August 1956 and was not impressed, likening it to London's Imperial War Museum in the layout, hanging and display.

The location of the gallery was another matter. The provincial

The Beaverbrook Art Gallery, circa 1959
The Beaverbrook Art Gallery Collection

government of New Brunswick allocated Officers' Square in Fredericton as the site and placed at Beaverbrook's disposal the provincial architect, Doug Jonsson. Beaverbrook rejected Jonsson's design, and he then engaged Fredericton architect Lynn Howell and his partner, Neil Stewart, to undertake the task. With the death of Howell shortly thereafter, Stewart took over the project. In a letter to Lord Beaverbrook dated 16 May 1955, Le Roux registers his concern over Stewart's plans regarding the inflexibility of the lighting system (which proved to be prophetic) and the lack of headroom in the basement. He also expresses concern over the proposed orientation of the building at ninety degrees to Queen Street and facing Officers' Square. Finally, Le Roux questions the architect's choice of sawn-faced granite,

hoping that it would have enough of a pink tinge. In another letter, written less than a month later, Le Roux laments the shortage of display space: "Apart from the change of design the great difference between the first architect's [Jonsson's] scheme and that of the second [Stewart] is a considerable reduction in area." Eventually, LeRoux recommended that the site occupied by the Fredericton Bicycle and Boat Club would be more suitable than Officers' Square, and Beaverbrook agreed. Permission to build on this site had to be secured, as the gallery would obliterate the Legislative Assembly's view of the St. John River. For the exterior, Beaverbrook selected a glazed brick in earth tones rather than granite. The original lighting system, designed by a Montreal firm, indeed proved disastrous and had to be rectified. Even so, Beaverbrook was finally content with the "gem" he had constructed on the banks of the St. John River, reflecting that he had derived more pleasure from establishing the Beaverbrook Art Gallery than from anything else.

In 1954, Beaverbrook had exhibited his personal collection of primarily British paintings at the University of New Brunswick's Bonar Law-Bennett Library. The enthusiastic public response had strengthened his resolve to build the Beaverbrook Art Gallery. A second exhibition followed at the library in 1955. This exhibition saw Canadian painting more fully represented, and also included British paintings by such masters as Reynolds, Turner and Constable, though the latter two later proved not to be autograph. The exhibition also included four of the historical British paintings that Beaverbrook had acquired in 1918 as part of the Canadian War Memorials collection.

Beaverbrook had a well-developed "programme" for the acquisition of pictures for his gallery: he wanted to focus almost exclusively upon British and Canadian painting. In a letter to Hugo Pitman dated 16 July 1956 he outlines that his purpose is to buy:

(1) Ten or twelve masterpieces. I already have four I
 can count on.

(2) 150 modern English paintings. I hope I have 65
 or 70 worthy of a place in the Gallery.

(3) 100 Canadian paintings. Here I seem to be better
 placed, and my present collection is more than
 halfway to my goal.

Hugo Pitman, Sir Chester Beatty and Douglas Cooper were among
the art connoisseurs to whom Beaverbrook turned "in my attempts to
straighten out my muddle." Still, Beaverbrook ultimately made his
own decisions. Although he shared Pitman's aversion to abstract art,
he resisted Beatty's exhortations that he include the Barbizon painters,
Diaz, Rousseau and Daubigny, and Cooper's suggestion that he
include Bonington. It was these experts' disinterested perspective that
Beaverbrook sought against the predations of the art trade. Often, he
would direct them to seek out real first-class paintings. Pitman, for
example, was asked to procure a John Singer Sargent.

On the front line, acting as intermediaries for Beaverbrook with
the art trade, were his secretary, Margaret Ince, Le Roux Smith Le
Roux and art consultant Marie Edmée Escarra de Ribes. Their role
was to find and present works to Beaverbrook for his approval. All of
Bond Street and the West End courted Beaverbrook's patronage,
including Knoedler, Agnew, Leggatt Brothers, Spink, Marlborough,
Wildenstein, Arthur Tooth and Sons, Alex Reid & Lefevre, John
Mitchell, the Parker Gallery, Leicester Galleries, Redfern Gallery,
Gimpel Fils, and Sotheby's and Christie's. In Canada, Beaverbrook
acquired Canadian pictures from the Dominion Gallery, Watson Art
Galleries, Walter Klinkhoff Gallery, Continental Galleries, Laing
Gallery and the Picture Loan Society.

Beaverbrook also engaged a battery of advisors from the art museum
community. Their job was to cast a critical eye on his purchases.

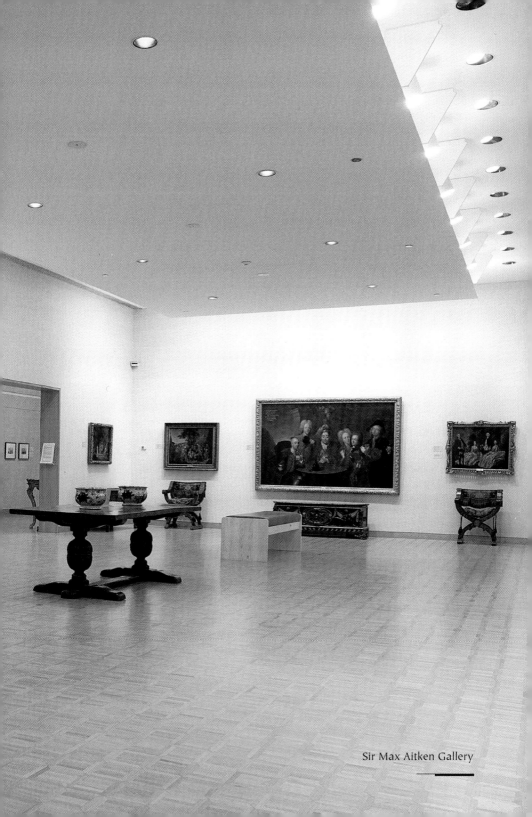

Sir Max Aitken Gallery

Beaverbrook once asked Sir John Rothenstein, director of the Tate Gallery, to examine a Constable that he had bought on the recommendation of Rothenstein's arch-enemy, Le Roux Smith Le Roux. Rothenstein doubted its authenticity. Among other museum professionals who were petitioned into action were Professor W.G. Constable, director of the Museum of Fine Arts, Boston; Alan Jarvis, director of the National Gallery of Canada; and John Steegman, director of the Montreal Museum of Fine Arts. Of Beaverbrook's omnivorous appetite for consultants, Michael Wardell wrote: "The art galleries of London, Paris, New York, Toronto and Montreal are littered with bodies of his discarded experts, some in chagrin, some in anger, and some, it must be said, in relief."

Another project that Beaverbrook assigned Le Roux was to organize the *Daily Express* Young Artists' Exhibition for 1955. In order to increase the number of modern British paintings in the gallery's collection, Le Roux suggested that Beaverbrook purchase "eight or ten of the paintings from the Exhibition." Le Roux consulted with Graham Sutherland, who was one of the jurors, as well as with Sir Herbert Read and Anthony Blunt. He also sought Sutherland's counsel with regard to the disputed Constable; Sutherland did not think it was a fake but that it had been "touched up" by another hand, which was reflected in the relatively low price of approximately £7,500. Sutherland suggested that Beaverbrook buy more works by such major artists as Wilson Steer, Walter Sickert and Matthew Smith. Beaverbrook heeded this advice but ignored Sutherland's further recommendation that he acquire paintings by artists whose work veered toward the abstract.

Beaverbrook was zealous in the extreme that his family, friends and business associates donate works of art to his collection. His sister, Jean Stickney, had to remove the Varley portrait of Beaverbrook's daughter, Janet, from the wall of her London house, where it had been permanently encased, for restoration and shipment to Fredericton.

Margaret Reid (left) with Lucile Pillow, circa 1959

Beaverbrook extracted twenty-two paintings by Cornelius Krieghoff from the mining magnate James Boylen by convincing him to return something to the province in which he made his fortune. Another mining entrepreneur and major art collector, Joseph Hirshhorn, donated six painting in the abstract idiom, including a Borduas and Nakamura.

Canadian press barons Roy Thomson, John W. McConnell and John Bassett all donated major Canadian pictures by Krieghoff, Emily Carr, and Lawren Harris, respectively. Canadian retailers W. Garfield Weston and Mr. and Mrs. John David Eaton were also added to the roster of donors. Canadian International Paper Company and Royal Securities, two companies in which Beaverbrook had an interest,

donated works by Copley and Krieghoff, and Canada Steamship Lines donated the anonymous *View of Fredericton,* 1823, in memory of Beaverbrook's childhood friend, Sir James Dunn, Bart. Early prints of Fredericton came unsolicited from Canadiana collector Sigmund Samuel, but Beaverbrook came away empty-handed in his attempt to cajole works for his gallery from Toronto collector Sam Zacks, whose donation would have added representation from the School of Paris.

Beaverbrook's courtship of prospective benefactors enriched the collection substantially. Sir William Orpen's mistress, Miss Cara Copland, provided a fine collection of Orpen drawings and paintings, not to mention a handsome bequest to the gallery as a residuary legatee of her estate.

Another perspicacious move on Beaverbrook's part was the appointment of Lucile Pillow of Montreal and St. Andrews, New Brunswick, to the gallery's original Board of Governors at its meeting on 17 March 1959. The appointment heralded the commencement of an association with this philanthropically inclined family that is now in its third generation. A collector of British porcelain and the work of James Wilson Morrice, Mrs. Pillow was also the beneficiary of the collection assembled by Charles and Elwood Hosmer, including a magnificent quartet of early Canalettos. Elwood Hosmer was the bachelor first cousin of Howard Pillow, Lucile Pillow's husband, and heir to the fortune of Charles Hosmer, his father, a fortune which derived mainly from the Canadian Pacific Railway, the Ritz Carleton Hotel and Ogilvie Mills Ltd. At her first board meeting, Mrs. Pillow, with characteristic generosity, offered the gallery a collection of British porcelain housed in specially designed display cabinets. This, in turn, was followed by the donation of paintings by Morrice and G. Horne Russell. Miss Olive Hosmer, Elwood Hosmer's sister, enhanced the collection by donating a collection of European miniatures along with paintings by G. Horne Russell, Maurice Cullen and John Constable, the latter

The Krieghoff Collection

purchased by her father, Charles Hosmer, from Scott & Sons, Montreal, in 1898.

Another summer resident of St. Andrews, Lady Dunn, widow of Beaverbrook's childhood friend, Sir James Dunn, Bart., was to exert a considerable influence over the direction of the gallery by virtue of her long-standing friendship with Lord Beaverbrook. Appointed to the Board of Governors at its meeting of 29 May 1959, Lady Dunn brought with her the connoisseurship acquired during her marriage to Sir James, along with his second collection. This collection was incorporated into the Sir James Dunn Foundation, which she founded after his death in 1956.

In his business and collecting activities, Dunn, five years Beaverbrook's senior, served as a role model. In 1914, because of financial reversals in his London brokerage firm, Dunn had been forced to disperse a collection comprising works by Holbein, Bronzino, Goya, Ruysdael and El Greco. Many of these paintings were acquired by Henry Clay Frick and now comprise part of his museum in New York. At the end of the First World War, Dunn began his second collection.

Lady Dunn's most celebrated gift to the gallery through the Sir James Dunn Foundation was Salvador Dali's *Santiago El Grande*, 1957, commissioned by the Spanish government for the Brussels World's Fair of 1958. The renown of this painting has made it the gallery's signature piece. As pendants to this work, the foundation also donated Dali's portraits of Sir James and Lady Dunn, *La Turbie*, 1949 and *Equestrian Fantasy*, 1954, respectively.

In 1960 and 1961 the Sir James Dunn Foundation donated some of the works acquired by Sir James for his second collection, including a collection of nudes by William Etty, paintings by Edwin Landseer and J.J.J. Tissot and portraits of Dunn by Walter Sickert and Augustus John. In 1970, the foundation sold its collection of seventy-nine works to the Beaverbrook Canadian Foundation. The collection included Sir

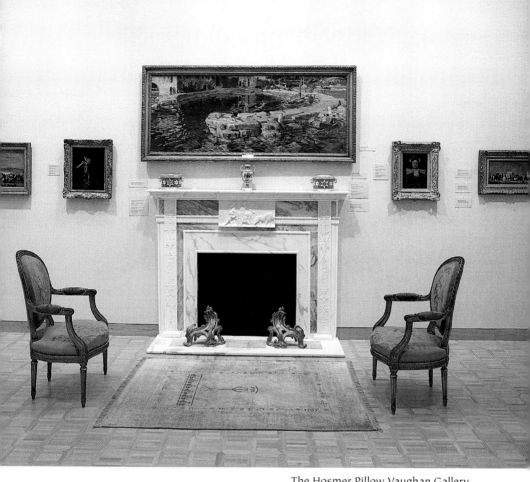

The Hosmer Pillow Vaughan Gallery

Third Baron Beaverbrook (left) and Director Ian Lumsden during the opening of *Sargent to Freud: Modern British Paintings and Drawings in the Beaverbrook Collection*, 1998

James's second collection, as well as some items that Lady Dunn had inherited through the estate of Lord Beaverbrook, whom she married in 1963. The collection is now housed within the Beaverbrook Art Gallery.

The Second Beaverbrook Foundation, which became the Beaverbrook Foundation in 1974, donated a collection of one hundred forty-one primarily nineteenth- and twentieth-century British paintings to the gallery between 1959 and 1961. The Beaverbrook Foundation still holds one hundred seventy-nine works, including several important eighteenth-century British paintings, within the gallery.

The original trust of one million dollars that Beaverbrook established on 15 April 1957 was projected to generate revenue of $60,000 per annum, $40,000 of which was to be designated for acquisitions. However, it soon became clear that all the revenue would be required to operate the gallery, leaving nothing for acquisitions. As a result the gallery was forced to rely upon gifts and the occasional acquisition grant from the Canada Council, which the gallery was obligated to match. In 1970, a gift from the Charles S. Band estate increased the

representation of works by the Group of Seven, and a gift from the Douglas M. Duncan estate provided works by David Milne and L.L. Fitzgerald. Canada Council grants in 1963 and 1969 saw the acquisition of works extending the representation of western Canadian artists. The 1963 grant allowed for the purchase of works by George Swinton, Ernest Lindner, Otto Rogers, Gordon Smith, Joe Plaskett and Jack Shadbolt. The 1969 grant enabled the gallery to acquire major works by the Regina Five, Donald Jarvis and Alistair Bell.

In 1972 the Beaverbrook Canadian Foundation established the Wallace S. Bird Memorial Collection in acknowledgement of the former chairman's contribution to the Beaverbrook Art Gallery. The initial grant of $20,000 was supplemented by another grant from the Beaverbrook Foundation along with two works by Miller Brittain. The purpose of this fund was to enhance the representation of Atlantic Canadian artists.

The appointment of Marguerite Vaughan of Montreal and St. Andrews to the Board of Governors in 1971 heralded a new era in the development of the collection and a continuation of the historical association of her mother, Lucile Pillow, with the gallery. Marguerite Vaughan's area of interest was Canadian and, in particular, Inuit art. In 1978 she donated to the gallery part of her collection of Inuit prints and provided funds for the acquisition of more than seventy works of art.

In 1976, the federal government established the Canadian Cultural Property Export and Import Review Board, part of whose mandate was to furnish Canadian museums with subsidies to assist in the repatriation of important cultural artifacts. Mrs. Vaughan frequently furnished the amount that had to be realized from the private sector to obtain these grants. The Beaverbrook Art Gallery has secured Movable Cultural Property grants over the past quarter century to acquire works with an aggregate value approaching one million dollars. Among these acquisitions have been paintings by Thomas

Lawrence, Thomas Gainsborough, Dominic Serres, George Chambers, Albert Bierstadt, A.Y. Jackson, J.E.H. MacDonald and Jack Bush.

In 1981 Marguerite and Murray Vaughan endowed the Hosmer Pillow Vaughan Gallery to house a collection of Continental fine and decorative art spanning seven centuries. The collection, assembled by Charles and Elwood Hosmer, has remained together through four generations, a unique distinction within the Canadian collecting community. At the same time the Beaverbrook Canadian Foundation funded the construction of the Sir Max Aitken Gallery, named in honour of Beaverbrook's son. This gallery showcases the British collection of seventeenth-, eighteenth- and nineteenth-century pictures primarily acquired by Lord Beaverbrook. Both galleries constitute part of the new east wing, which opened to the public in 1983.

In 1991, Marguerite and Murray Vaughan's children, David Vaughan and Lucinda Flemer, donated an important collection of Canadian and European paintings and sculpture as executors of the estate of their mother. Works by Riopelle, Borduas, Varley and Milne strengthened the Canadian holdings, and works on paper by Matisse and Marini augmented the European presence. In 1993 and 1996 Mr. and Mrs. John Flemer and the executors of the estate of David H.M. Vaughan transferred title for the Hosmer Pillow Vaughan Collection to the Beaverbrook Art Gallery, affording the gallery the distinction of holding the finest European collection in Canada east of Montreal.

Through the generosity of Marion and Harrison McCain, the Marion McCain Atlantic Art Exhibition was inaugurated as a biennial event in 1987. The exhibition reflected the family's interest in contemporary art of the Atlantic Provinces. To provide a permanent facility for the exhibition of the art of Atlantic Canada, Harrison McCain constructed the Marion McCain Atlantic Gallery, which opened in 1995. Harrison McCain has built upon the gallery's existing holdings to create the finest collection of Atlantic Canadian art in the world. Through his own personal generosity and that of his

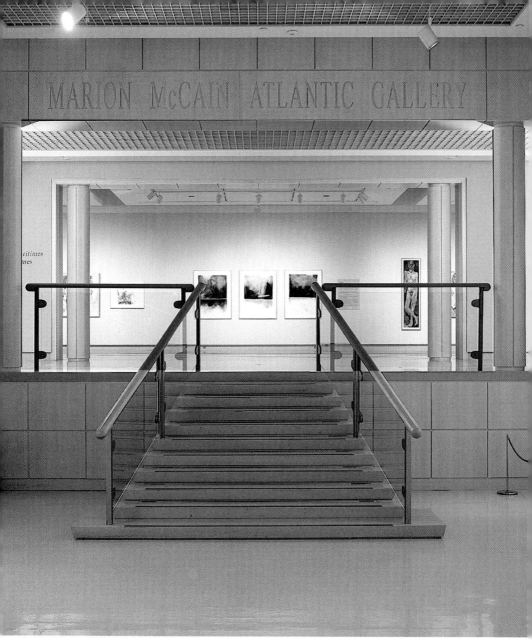

The proscenium entry of the Marion McCain Atlantic Gallery

Left to right: Ann McCain Evans, Chris Evans, Harrison McCain, Gillian McCain, Mark McCain, Joyce McCain, Peter McCain and Laura McCain at the official opening of the Marion McCain Atlantic Gallery, 1995

friends and business associates, including James Coutts and Christopher and Mary Pratt, works by Colville, Blackwood, the Pratts, and Molly and Bruno Bobak have been added to the collection. In 1997, in an unprecedented act of generosity, Bruno Bobak donated eighty works covering over thirty years of his creative life, establishing the gallery as the undisputed centre for the study of the work of this important Canadian figurative painter. The gallery can make a similar claim for the work of Jack Humphrey and Christopher Pratt.

Continuing the strong tradition of family support within the Beaverbrook Art Gallery, the children of Harrison and Marion McCain are carrying on their parents' association with the gallery.

Timothy Aitken, Custodian of the Beaverbrook Art Gallery, with Graham Sutherland's *Portrait of Lord Beaverbrook*, 1995

Ann McCain Evans has ably assumed the mantle of her mother as sponsor of the Marion McCain Atlantic Art Exhibition. Harrison McCain's children have assisted with the acquisition of a major work by A.Y. Jackson and donated a work by Allan Mackay as well as commissioning a suite of photographs by Robin Collyer in memory of their late brother, Peter.

In 1992 the federal government contributed two million dollars towards the establishment of the Senator Richard Hatfield Memorial Fund, which commemorates the contribution to the arts of this former chairman of the Board of Governors of the gallery and premier of the province of New Brunswick. A substantial portion of the revenue from this fund has been designated for the acquisition of

works of art. With the matching support of the Canada Council for the Arts' Acquisition Assistance Program, the gallery has been able to purchase major works by such internationally acclaimed Canadian artists as Attila Richard Lukacs, John Greer and Geneviève Cadieux. Periodically the gallery is invited to apply for funds from such private foundations as the Gelmont Foundation, which enabled the gallery to acquire a major painting by Guido Molinari.

The nature of an institutional collection comprising a series of collections assembled by private individuals is inevitably different than a collection systematically acquired over the years through predictable government funding by a series of curators with an acquisitions policy. It is bound to be more varied and uneven, reflecting as it does the passions and the biases as well as the social and political orientation of the collectors. It also poses a greater challenge to the curator, who must try to mould it into a coherent shape and strive to maintain its quality without suppressing the personality of the collectors. The curator must also try to acquire new collections that will furnish a context, provide depth or keep the collection moving forward. The consistent quality of the state-funded collection with its greater comprehensiveness stands in counterpoint to the more mercurial and autographic quality of the private collection as the mirror of the collector's soul.

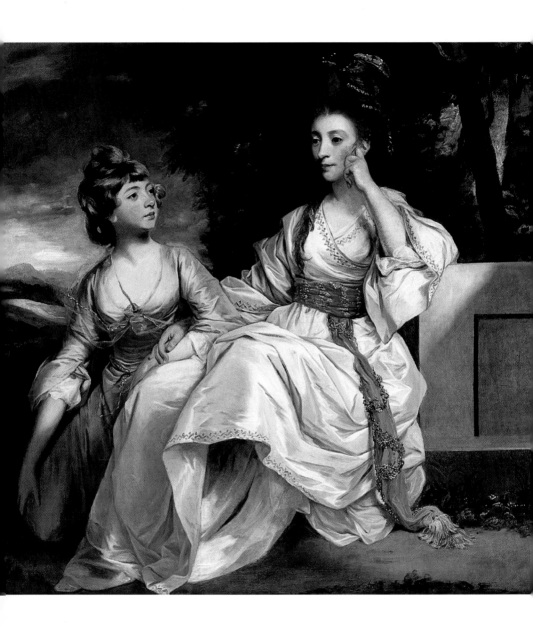

JOSHUA REYNOLDS (British, 1723-1792)
Mrs. Thrale and her Daughter Hester (Queeney), 1781
oil on canvas, 148.6 x 140.3 cm
Gift of Lord Beaverbrook

Ian G. Lumsden

The profound differences between the character of British art and that of southern Europe are attributable to the many changes in religion and politics brought about by the Reformation. With the recognition of Henry VIII as Supreme Head of the Church in England through the Convocation of Canterbury in 1531, British art saw the synthesis of the two primary sources of patronage, namely the church and state, into one.

With the creation of a Protestant state the old religious themes were denied to the artists, and, indeed, Archbishop Cranmer under Edward VI ordered the removal and destruction of all images that were objects of pilgrimage. The effects of the Reformation in England on the course of British art were to be more profound than the simple eradication of religious imagery. In England there emerged a suspicion about art, other than portraiture, because it connoted heresy and idolatry. This legacy of puritanical hostility towards art has proven an impediment to British painters right up to the twentieth century.

With the decline of religious imagery, portraiture became a dominant art form in England. Nowhere is the primacy of portraiture to British art better reflected in Canada than in the collection of the Beaverbrook Art Gallery. Lord Beaverbrook, who had a natural attraction to the portrait genre in the art of Britain, the country of his adoption, resolved to build a fine collection of British portraits for the gallery he was building for the people of New Brunswick.

Although he was unable to secure one of the celebrated portraits of Henry VIII by Hans Holbein, Beaverbrook did manage to acquire an important miniature portrait of another Tudor monarch, Henry's

daughter Elizabeth I, by the court painter Nicholas Hilliard (48). Miniature painting was essentially a court art and belonged primarily to the reign of Elizabeth I. Of equally significant status is the only extant religious painting by Isaac Oliver, *Madonna and Child in Glory* (49), produced circa 1610. Unique by virtue of having been painted in an iconoclastic country, the painting may have been commissioned by Anne of Denmark, consort of James I. Anne's crypto-Catholicism was well known, and Oliver was her court painter.

British painting in the sixteenth and seventeenth centuries witnessed the ascendancy of foreign painters, who came mainly from the north of Europe and especially from the Netherlands. The heightened realism of the portraits of Oliver and his brother-in-law, Marcus Gheeraerts, anticipates the work of Dutch painters Daniel and Jan Mytens. This period finds representation in a painting by Jan Mytens, *The Cotterell Family*, 1658 (50), painted while the family was living in self-imposed exile on the Continent during the Commonwealth. Sir Charles Cotterell, Master of Ceremonies to Charles I, is portrayed with his wife and two sons and two daughters, possibly in some valley in the Ardennes. The family spent part of their exile at Antwerp and later moved to The Hague.

The Cotterell Family also reflects the introduction of a new genre of painting, the "conversation piece." These smaller, informal group portraits better accommodated the smaller English country homes than the larger "Grand Manner" full-length portraits, and the sitters were characterized by a refinement and casual elegance combined with an underlying arrogance that has come to be one of the hallmarks of the British aristocracy. The development of the conversation piece genre in England can be attributed in part to the arrival of Flemish painter Anthony Van Dyck in England in 1632 and was also influenced by the "fête champetre" of the French Rococo period. Philippe Mercier, a student of Watteau, is often credited with transplanting this form of group portraiture from French to English soil with his work of the late

1720s and the early 1730s. An excellent example is *Bacchanalian Piece: Sir Thomas Samwell and Friends* (51), executed around 1733. Mercier was indentured to Samwell of Upton House, Northamptonshire, from 1732 to 1738, during which time he painted portraits and group portraits of Samwell's friends.

An even greater practitioner of this genre was William Hogarth, who delighted in creating satirical portrayals of the gentry and professional classes. His father-in-law, Sir James Thornhill, also a painter, was anxious to establish a national school that would at last see patrons champion British over foreign artists. Hogarth strongly endorsed these sentiments and established the first exhibiting society, a precursor to the Society of Artists and the Royal Academy. Hogarth's frustration with the popularity of Rembrandt's etchings in England in the early 1750s provoked him to paint the portrait of his engraver friend, *John Pine* (53), in 1755, imitating Rembrandt's style to fool collectors. Based upon a mezzotint of an early Rembrandt self-portrait, Hogarth's imitation was so convincing that in 1948 Christie's presented it in their salesroom as a school version of a Rembrandt self-portrait.

In spite of the popularity of the conversation piece, "Grand Manner" portraiture still occupied an important place in British painting in the second half of the eighteenth century and embodies much that was distinctive about the character of British painting in the Age of Enlightenment. Its two principal practitioners were Joshua Reynolds and Thomas Gainsborough. Reynolds, president of the Royal Academy and author of the *Discourses*, sought to imbue the genre of portraiture with *gravitas* by employing the compositional range and depth of Renaissance masters such as Raphael and Michelangelo. Reynolds sought to elevate the status of his sitters by the employment of poses deriving from antiquity or other art historical references. For example, in his portrait *Mrs. Thrale and her Daughter Hester (Queeney)*, 1781 (34), Reynolds painted his subjects in a pose taken from an ancient tomb relief from Palmyra.

Gainsborough similarly looked to the past, but in the case of his portraiture, it was to the work of Van Dyck. In contrast to the academic pretensions of Reynolds, Gainsborough desired to create a musical harmony and pastoral mood through the use of loosely scumbled transparent glazes. Gainsborough's adoption of a low perspective and a pose of swaggering nonchalance in his portrait *Lieutenant-Colonel Edmund Nugent*, 1764 (56) imbues the sitter with a courtly elegance set within an artificial landscape.

The attraction of Italy in terms of traditional values in art, extending back to the Renaissance and beyond to classical antiquity, was profound. Italy was a popular destination for young milords anxious to complete their classical education through the Grand Tour and for artists eager to profit from the example of their Italian contemporaries, in particular the portraitist Pompeo Batoni. One portraitist to benefit from his sojourn in Rome and Naples was the Scottish painter Allan Ramsay. In the Beaverbrook Art Gallery's trilogy of Ramsay portraits from the 1740s, *John, 1st Earl of Upper Ossory*, 1744, *Admiral William Martin*, 1747 and *Victoria Kynaston*, 1749 (52), we see Ramsay before he came under the influence of the portraitists of the French Rococo, such as Nattier, Perronneau and de la Tour.

The demand of the aristocratic Grand Tourist for souvenirs of his sojourn in Italy created a market for *veduta*, or scene painting, in England that resulted in the creation of a native-born industry. Within this genre was the *veduta essaiata*, which recorded the actual topography of the landscape, and the *veduta ideata*, or imaginary landscape, which was a confection of the artist's imagination. Somewhere in between lies the *capriccio*, an amalgam of real architectural structures and identifiable landscape elements assembled in a fanciful manner. Claude-Joseph Vernet's *A Grand View of the Sea Shore in the Mediterranean, Enriched with Buildings, Shipping and Figures*, 1776 (57) falls within the *capriccio* genre. In this painting, the *torre* (tower) on the left is reminiscent of the *torre* at Volturno, situated in a locale that

bespeaks the Tyrrhenian Sea somewhere between Ostia and Naples. Commissioned by Lord Shelbourne, later the Marquess of Lansdowne, for Lansdowne House at a cost of 7500 French livres or 500 guineas, the work was likely intended as a memento of Lord Shelbourne's own Grand Tour of Italy. It eventually found its way into the collection of the Dukes of Westminster; the third duke returned it to the market whence Beaverbrook acquired it from Thos. Agnew and Sons.

The patronage that the arts were enjoying in England as a result of the wealth accrued by its vast network of colonies attracted such Italian artists to England as Sebastiano Ricci, Pellegrini, Amigoni and Antonio Canaletto, the latter arriving in 1746. It was the influence of Canaletto and other veduta painters, or *vedutista,* who were responsible for cultivating a taste for the landscape genre among English collectors. Because of England's ever expanding colonial empire, the art of the topographer took on an enhanced importance, and Woolwich Academy trained numerous topographers under Paul Sandby to record this new terrain.

Sketches by Richard Short, who served as topographer and purser on the H.M.S. Orange at the Battle of the Plains of Abraham, served as source material for the twelve paintings of Quebec after the conquest executed by Dominic Serres. Two paintings from this series, *The Bishop's House with the Ruined Town of Quebec, the St. Lawrence Beyond* and *The Intendant's Palace, Quebec* (55), both executed in 1760, were purchased by the Beaverbrook Art Gallery from Sotheby's (London) in 1992 with funds from a Minister of Communications Cultural Property grant.

The cultural transfer that saw the New World furnish new subject matter for the eighteenth-century British-trained topographer also witnessed a reverse migration of artists from the colonies in search of training and exhibition opportunities at the Royal Academy in London, founded in 1768. John Singleton Copley left the colonies for London on the eve of the Revolutionary War. Enrolling at the Royal Academy

in 1775, he quickly became a disciple of Reynolds. As a largely self-taught artist who had grown up in Boston, he deployed the compositional devices found in mezzotints after Kneller and Hudson to create his portraits *Abigail Belcher* (54) and *Chief Justice Jonathan Belcher,* respectively, as a young man of 19 in 1756.

Another Grand Manner portrait from this period is Thomas Lawrence's *A Portrait Group of Mrs. John Thomson and her Son Charles Edward Poulett Thomson, later Baron Sydenham of Sydenham, Kent, and of Toronto, and Governor-General of British North America,* circa 1806 (59). This painting was once part of the collection of Oscar Cintas, Cuban ambassador to the United States. The gallery purchased it in 1990 with funds from a Minister of Communications Cultural Property grant and the Beaverbrook Canadian Foundation. Lawrence, who succeeded Reynolds as the pre-eminent portraitist of his time, was president of the Royal Academy from 1820 to 1830. Lawrence's deliberately awkward composition in the "Regency Mannerist" style contrasts with the informal elegance of George Romney's earlier portrait of another colonial governor of Upper Canada, *Charles Lennox, later 4th Duke of Richmond, Duke of Lennox and of Aubigny,* circa 1776 (58). Lennox was governor from 1818 to 1819.

The ascendancy of landscape painting in eighteenth-century England can trace its origins to seventeenth-century Dutch landscape painting as well as to the *vedutista* of eighteenth-century Italy. Up to the middle of the century the taste for the contrived picturesque compositions of Claude and the Poussins had prevailed among British collectors. The importance attached to land ownership, the enclosures of common land and the interest in the landscape architecture associated with the English country house created a market for the atmospheric confections of Richard Wilson and Thomas Gainsborough. Gainsborough's early Suffolk-period landscapes manifest his debt to such seventeenth-century Dutch landscapists as Both, Wynants and Pynacker.

As the eighteenth century advanced, the development of the "Picturesque" movement led to a new appreciation of British scenery. Prior to the Romantic period (1750-1850), landscape had functioned primarily as a background for other genres. In the Romantic period landscape took on a multitude of meanings, emotional, intellectual and moral. Deriving his inspiration from James Thomson's poem *The Castle of Indolence* (1748), Joseph Mallord William Turner painted *The Fountain of Indolence* (61) in 1834 as a fantastical landscape, with a nod to Claude in the deployment of figures from antiquity and the classical compositional construct. Beaverbrook acquired the painting from the Vanderbilt Collection. In *Scene of Woods and Water*, circa 1830 (60), a rejected portrait background study, John Constable imbues the ordinary coastal landscape with a pantheistic fury. Given to the Beaverbrook Art Gallery by Miss Olive Hosmer, this scene resembles a reversal of *Hadleigh Castle* and represents a covenant of sorts.

Contemporary history painting became popularized by the success of Copley and Benjamin West as is manifested in the work of fellow Royal Academician and Marine Painter to King George IV, George Chambers. *The Crew of H.M.S. 'Terror' Saving the Boats and Provisions on the Night of 15th March 1837* (62) was painted after sketches by the *Terror*'s hydrographer, William Smyth, and illustrations in the logbook kept by Admiral Sir George Back. The drama of this painting nicely encapsulates Edmund Burke's concept of the *sublime* that colours the Romantic movement in England.

The walls of the Royal Academy in the nineteenth century were almost exclusively devoted to the Schools of Landscape and Incident. According to the philosophy of the School of Landscape, artists were now explorers who responded to the taste of the Victorian "armchair traveller." Images of Rome made popular by the Grand Tour, such as David Roberts's canvas *Rome, View on the Tiber Looking towards Mounts Palatine and Aventine*, circa 1863 (64), were still popular, but

so were portrayals of more exotic locales, such as Turkey, the Middle East and Egypt.

Genre subjects – domestic subjects focusing upon quotidian experiences, often of middle- and lower-class people – in British art were first popularized by David Wilkie and were partially rooted in the tradition of Teniers and seventeenth-century Netherlandish painting. Following in the wake of Wilkie is Thomas Webster, who is celebrated for his portrayal of Victorian childhood antics. His work is brilliantly represented in *A Slide*, 1849 (63), given to Beaverbrook by the staff of the Beaverbrook Newspapers. Thomas Faed's *When the Day is Done,* 1870 (68), shown to great acclaim at the Royal Academy in 1870, is a pious representation of a Highland peasant family elevated to the status of a religious icon. These romanticized images ennobling the lot of the peasant were popular among Industrialist collectors anxious to alleviate their guilt for acquiring their new wealth through the exploitation of the working class.

The course of love in the School of Incident was a preoccupation of J.J.J. Tissot, whose paintings depict lovers buffeted about and restrained by a Victorian sense of propriety. Tissot set up house-keeping in St. John's Wood with Kathleen Newton, a young widow, for which he had to pay a price. Although keeping a mistress, if not sanctioned by society, was at least condoned, living common-law was unacceptable. Many of Tissot's paintings were autobiographical, and almost all used Kathleen as a model. *A Passing Storm,* circa 1876 (70), chronicles one such encounter with an almost Jamesian quality in its reluctance to moralize.

The School of Incident, which filled the walls of the Royal Academy with paintings of sentimental and trivial subject matter, was anathema to a group of artists led by Dante Gabriel Rossetti. In 1848, in reaction to this lowbrow art, Rossetti established a secret association of young artists known as the Pre-Raphaelite Brotherhood. Their desire was to return to Italian art before Raphael in search of subject matter that was

direct, serious and heartfelt. John Everett Millais, one of the artists who founded the brotherhood, continued to explore subject matter from the past even after the brotherhood effectively dissolved in 1852. Millais created the fine ink drawing *James VI Taking an Affectionate Farewell of His Scottish Subjects in St. Giles' Church Previous to His Departure to Assume the Crown of England*, circa 1870 (69). The Pre-Raphaelite style, inspired by the fourteenth- and fifteenth-century frescoes at Pisa, is manifested in this strong contour drawing, which is devoid of the mannerist contortion and deformation popularized by Raphael and those who followed him.

A second wave of Pre-Raphaelite activity dominated by Rossetti and Edward Burne-Jones followed in the 1860s and 1870s. Burne-Jones's preparatory red chalk drawing, *Portrait of a Young Woman*, circa 1865 (65), reflects the influence of Rossetti and, to a lesser extent, Botticelli, to whose work he was introduced on a trip to Italy in 1859. Another artist who was influenced by Rossetti was Marie Spartali Stillman, whose pastel drawing *Girl with White Roses, Self-Portrait* (66) bears Rossetti's monogram, presumably added by someone several years later. Another disciple of the brotherhood was Ford Madox Brown, who profoundly influenced Rossetti. In 1865 Brown began to design stained glass windows for William Morris. *The Expulsion from the Garden of Eden,* 1869 (67) was Brown's design for the apse of Meole Brace, near Shrewsbury, manufactured in glass by Morris and Co. in 1870.

As an antidote to the social problems created by the urban industrialized world of the town, many artists turned to escapist modes of expression in the latter part of the nineteenth century. The classical revival as a gentle form of evasion could be found in the work of Frederick Leighton, Lawrence Alma-Tadema, Edward Burne-Jones and John Waterhouse. Waterhouse took his subject matter from classical mythology and literature. His *Study for Miranda, The Tempest* (71) is from Shakespeare's play.

This sort of escapist painting, which was the stock in trade of the

annual Royal Academy exhibitions, created a strong reaction from the younger artists, who were beginning to attach more importance to formal and aesthetic values. In 1886 the New English Art Club was founded, and by 1880 many young British artists were going to Paris for their artistic education. The New English Art Club soon supplanted the Royal Academy as exhibitor of the work of progressive younger artists, and the Slade School, founded in 1871, created strong competition for the teaching arm of the Royal Academy. In 1891 Henry Tonks was appointed assistant professor at the Slade, and he brought to his students his admiration for Manet and Degas. The influence of these two Impressionists can be seen in Tonks's modern conversation piece, *Hunt the Thimble,* 1909 (72). The Slade attracted such talented young artists as Augustus John, Harold Gilman and Spencer Gore.

With the diminution of the role of the patron by the 1870s, artists began to lose contact with the public and became more self-referential in their explorations, with a concomitant rejection of "tradition." Possibly the most cataclysmic events in the history of British painting were the two exhibitions organized by Roger Fry for the Grafton Gallery in 1910 and 1912, *Manet and the Impressionists* and the *Second Post-Impressionist Exhibition,* respectively. In the 1912 exhibition, Fry decided to include British artists whose work evinced a concern for formal values. One such artist was Harold Gilman. Gilman had seen Van Gogh's work at Fry's 1910 exhibition; the saturated palette and staccato brushwork of *The Verandah, Sweden,* 1912 (73) betrays Van Gogh's influence.

Partly in reaction to the popularity of escapist subject matter in the art of the latter part of the nineteenth century, Walter Richard Sickert, Harold Gilman, Spencer Gore and Robert Bevan founded the Camden Town Group in 1911. The group pronounced modern, everyday scenes from the urban townscape fit subject matter for an artist, and often rendered these scenes in an impressionistic style. Sickert's

Sunday Afternoon, circa 1912 (74) portrays a scene of marital discord being acted out in a seedy bed-sitter. Sickert's tendency to block out his compositions into positive and negative values anticipates his harnessing of the medium of photography to create his twentieth-century Grand Manner portraits in the 1930s. His portrait *H. M. King Edward VIII*, 1936 (81) derives from a press photograph by Harold J. Clements, in which the king's reluctant countenance presages his abdication.

The first group of artists in Britain to embrace non-objectivity in visual art were the Vorticists, who derived their inspiration from Marinetti and the Italian Futurists. Whereas the Futurists' manifesto was the rejection of the prevailing academicism of Italian art in favour of modernity, technology, speed and the power of the machine, the Vorticists, established in 1914 by Wyndham Lewis with the support of Edward Wadsworth, David Bomberg, Frederick Etchells and Ezra Pound, wanted to create an art verging on the totally abstract. The group disbanded in 1915, largely due to public indifference to their work but also because they had become aware of the destructive capacity of modern technology; their romance with and veneration of technology was shattered by the death of several of their number in the Great War. Lewis and Wadsworth were later to come under the influence of André Breton's Surrealist credo, as witnessed in Lewis's *The Mud Clinic*, 1937 (82) and Wadsworth's *The Jetty, Fécamp*, 1939 (83).

Although the 1920s were generally a fallow period in British art, there emerged an interest in naïve art centred in the community of St. Ives, Cornwall, with a retired fisherman, Alfred Wallis, as its progenitor. Wallis's work became a touchstone for that of Christopher Wood and Ben Nicholson. Wood synthesizes the pictorial immediacy of Wallis's naïve paintings with the compositional complexity of Braque in *Window, St. Ives, Cornwall*, 1926 (77). Nicholson further flattens the pictorial space by the deployment of a reduced number of abstracted

objects in *Still Life on a Table*, circa 1930 (79). Another member of this community was Barbara Hepworth, who became interested in the surreal subject matter of the operating ampitheatre. Although primarily a sculptor, Hepworth shared her colleagues' interest in compressing figures in a shallow picture plane, as convincingly demonstrated in her painting *The Operation: Case for Discussion,* 1949 (85).

The early works of William Orpen and Augustus John have a lyrical charm deriving in part from the influence of the Post-Impressionists. This influence can be seen in John's portrait of his second wife, *Dorelia,* circa 1916 (76). But by the 1920s both artists had reverted to creating the types of academic portraits that covered the walls of the Royal Academy and were the bread and butter for those artists and most others. Sir James Dunn commissioned Orpen to do a portrait of his eldest child, *Mona Dunn,* circa 1915 (75), and commissioned John to do one of himself, *Sir James Dunn,* 1929 (78), painted at his estate at Saint-Jean-Cap-Ferrat.

Although the history of painting in Britain and on the Continent in the twentieth century tends to be determined by group movements, there were eccentric geniuses such as Stanley Spencer and Laurence Stephen Lowry, whose work did not conform to any of the mainstream movements. Spencer engaged the people of Cookham to recreate the Christian story in a contemporary rural setting in *The Marriage at Cana: A Servant in the Kitchen Announcing the Miracle,* 1952-53 (87). Lowry makes the vernacular style his own in his portrayal of the industrial Midlands, *Industrial View, Lancashire,* 1956 (90).

Matisse's art celebrated the materiality of paint above and beyond its capacity to be a representation of anything. Two painters in the gallery's collection who more completely synthesized this view were Matthew Smith and Samuel Peploe. Smith's brief period of study with Matisse in 1910 is reflected in *Pears with Red Background,* 1947 (84), which evokes the master's *Le studio rouge,* 1911. Peploe enjoyed a

similar exposure to the work of the Post-Impressionists during his stay in Paris from 1910 to 1913. The influence of the Post-Impressionists can be seen in *Tulips and Oranges*, circa 1932 (80), with its vigorous brushwork and saturated palette.

The twentieth century witnessed a coterie of artists who secured for themselves international reputations, among them Graham Sutherland, Lucian Freud and Henry Moore. Beaverbrook liked to take some credit for Sutherland's mid-career switch to portraiture; he had commissioned the artist to paint his own portrait, *Lord Beaverbrook,* 1951 (86), and had encouraged Sutherland to accept the commission of the House of Lords and the House of Commons to paint Winston Churchill, *Study of Churchill, Grey Background,* 1954 (89). Beaverbrook recognized the genius of Lucian Freud early in that artist's career. He purchased Freud's *Hotel Bedroom,* 1954 (88) from the 1955 *Daily Express* Young Artists' Exhibition. Because Beaverbrook was reluctant to embrace those artists whose work embodied formal or abstract values, he did not offer his patronage to Henry Moore. It was left to the Beaverbrook Foundation to swap a Sutherland oil sketch of Churchill for the bronze *Three-quarter Figure,* 1961 (91) with dealer Alfred Hecht. More recently Moore's representation in the collection has been enhanced through the generosity of Montreal collector George J. Rosengarten, O.C.

Because Beaverbrook did not adequately provide for the growth of the British Collection, the gallery has relied upon the beneficence of private collectors to remedy omissions and furnish depth. However, the gallery has now undertaken to acquire some works that are representative of the past forty years of the twentieth century, when many of Britain's artists at last achieved international acclaim, something that was largely denied their forebears.

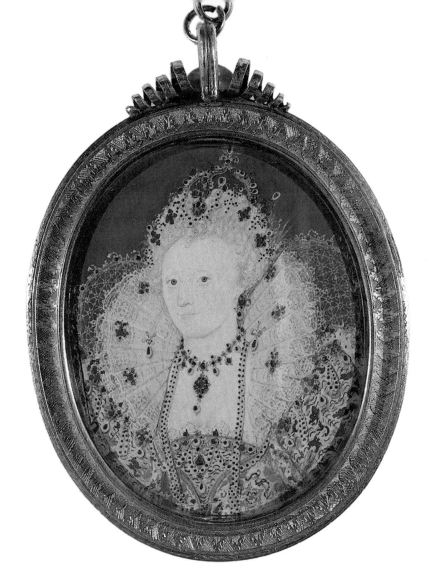

NICHOLAS HILLIARD (British, 1547-1619)
Queen Elizabeth I, date unknown
gouache on ivory card, 6.03 x 4.8 cm
The Beaverbrook Foundation

Facing page:
ISAAC OLIVER (British, c.1565-1617)
Madonna and Child in Glory, c.1610
gouache on vellum laid down on panel, 27.6 x 20.3 cm
The Beaverbrook Foundation

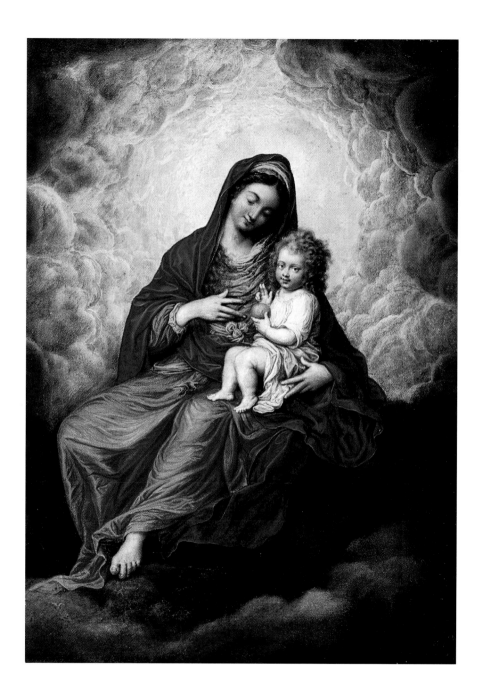

JAN MYTENS (Dutch, 1614-1670)
The Cotterell Family, 1658
oil on canvas, 119.4 x 181.6 cm
The Beaverbrook Canadian Foundation

PHILIPPE MERCIER (French, 1689-1760)
Bacchanalian Piece: Sir Thomas Samwell and Friends, c.1733
oil on canvas, 148.6 x 239.4 cm
The Beaverbrook Foundation

ALLAN RAMSAY (British, 1713-1784)
Victoria Kynaston, 1749
oil on canvas, 127.0 x 101.6 cm
The Beaverbrook Canadian Foundation

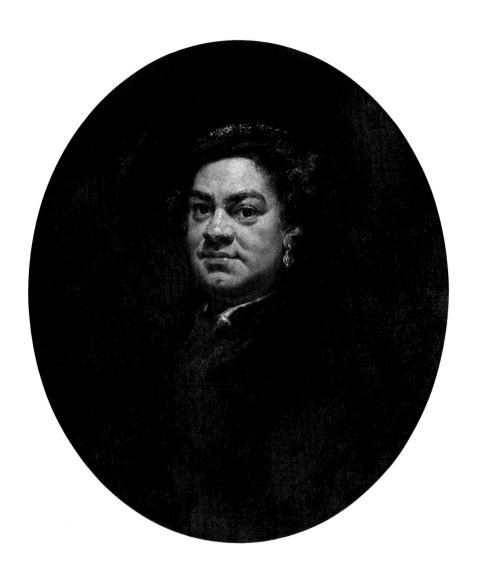

WILLIAM HOGARTH (British, 1697-1764)
John Pine, c.1755
oil on canvas, 73.7 x 63.5 cm
The Beaverbrook Foundation

JOHN SINGLETON COPLEY (American, 1738-1815)
Abigail Belcher, 1756
oil on canvas, 124.5 x 101.9 cm
Gift of the Canadian International Paper Co.

DOMINIC SERRES (British, 1722-1793)
The Intendant's Palace, Quebec, 1760
oil on canvas, 33.6 x 52.0 cm
Purchased with funds from a Minister of Communications Cultural Property Grant
and the General Purchase Fund

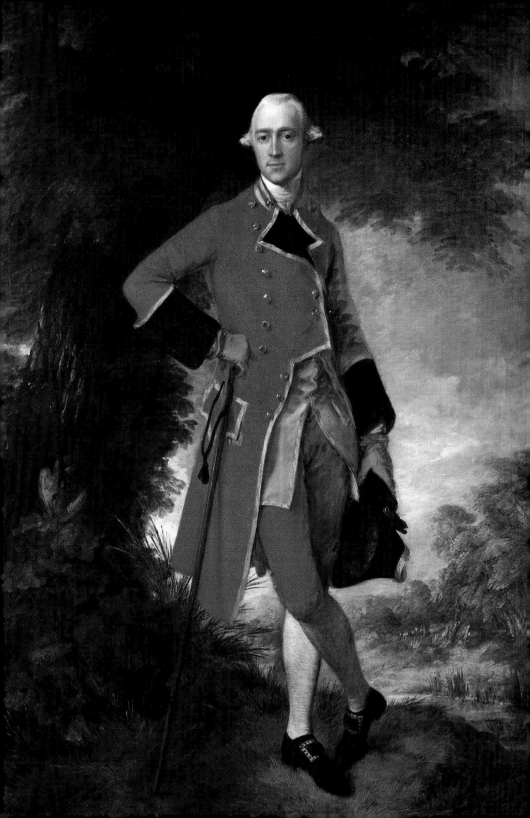

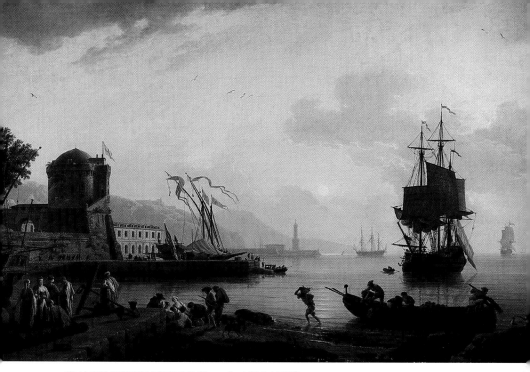

CLAUDE-JOSEPH VERNET (French, 1714-1789)
A Grand View of the Sea Shore in the Mediterranean, Enriched with Buildings,
Shipping and Figures, 1776
oil on canvas, 162.6 x 261.0 cm
The Beaverbrook Foundation

Facing page:
THOMAS GAINSBOROUGH (British, 1727-1788)
Lieutenant-Colonel Edmund Nugent, 1764
oil on canvas, 233.7 x 154.9 cm
The Beaverbrook Foundation

GEORGE ROMNEY (British, 1734-1802)
Charles Lennox, later 4th Duke of Richmond, Duke of Lennox and of Aubigny,
1776-77
oil on canvas, 127.6 x 101.6 cm
The Beaverbrook Canadian Foundation

THOMAS LAWRENCE (British, 1769-1830)
A Portrait Group of Mrs. John Thomson and Her Son Charles Edward
Poulett Thomson, later Baron Sydenham of Sydenham, Kent, and of Toronto,
and Governor-General of British North America, c.1806
oil on canvas, 224.2 x 147.3 cm
Purchased with a Minister of Communications Cultural Property Grant
and funds from the Beaverbrook Canadian Foundation

JOHN CONSTABLE (British, 1776-1837)
Scene of Woods and Water, c.1830
oil on canvas, 76.8 x 63.5 cm
Gift of Miss Olive Hosmer

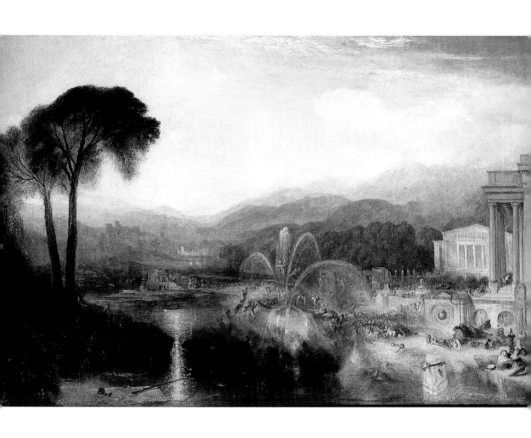

JOSEPH MALLORD WILLIAM TURNER (British, 1775-1851)
The Fountain of Indolence, 1834
oil on canvas, 105.7 x 166.4 cm
The Beaverbrook Foundation

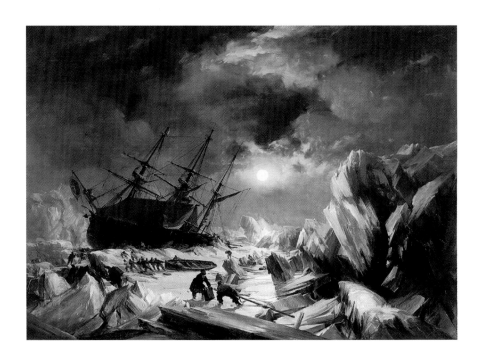

GEORGE CHAMBERS (British, 1803-1840)
The Crew of HMS 'Terror' Saving the Boats and Provisions
on the Night of 15th March 1837, 1838
oil on canvas, 60.3 x 83.8 cm

Purchased with a Minister of Communications Cultural Property Grant and funds
from Friends of the Beaverbrook Art Gallery

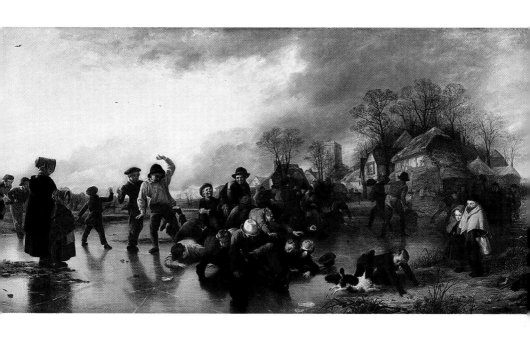

THOMAS WEBSTER (British, 1800-1886)
A Slide, 1849
oil on canvas, 77.2 x 154.0 cm
The Beaverbrook Canadian Foundation

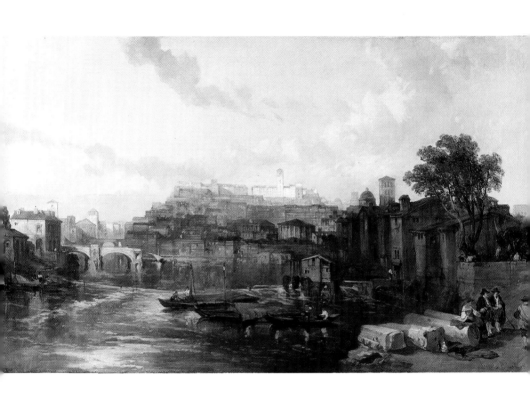

DAVID ROBERTS (British, 1796-1864)
Rome, View on the Tiber Looking Towards Mounts Palatine and Aventine, c.1863
oil on canvas, 62.2 x 107.3 cm
Gift of Lord Beaverbrook

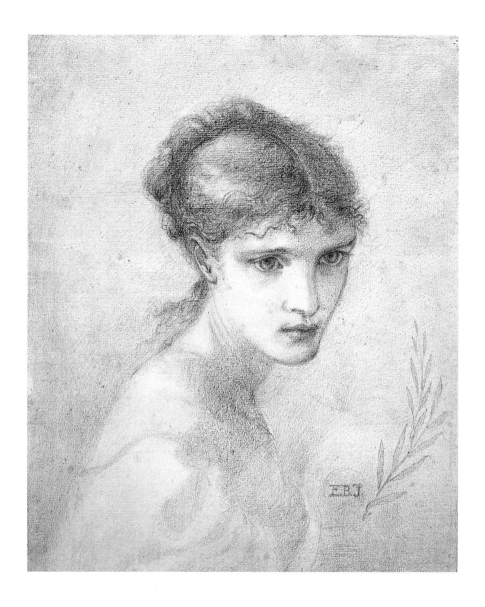

EDWARD COLEY BURNE-JONES (British, 1833-1898)
Portrait of a Young Woman, c.1865
red chalk on vellum, image: 35.2 x 30.2 cm, support: 37.5 x 30.5 cm
Gift of Mr. George J. Rosengarten, O.C.

MARIE SPARTALI STILLMAN (British, 1844-1927)
Girl with White Roses, Self-Portrait, not dated
pastel on paper, 61.3 x 51.8 cm
Gift of the Second Beaverbrook Foundation

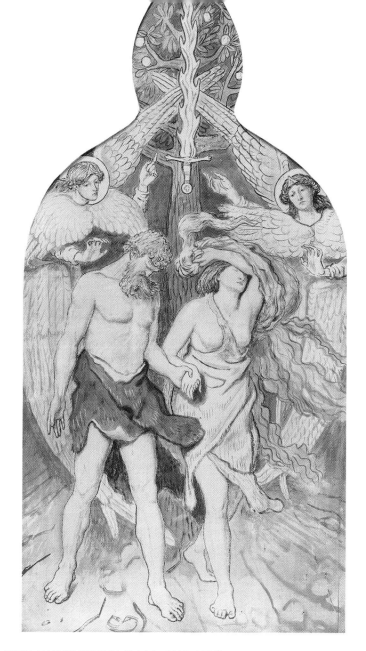

FORD MADOX BROWN (British, 1812–1893)
The Expulsion from the Garden of Eden, 1869
pencil, black ink, black chalk and grey wash on irregularly shaped paper
image: 99.1 x 51.4 cm, support: 99.7 x 53.0 cm
Gift of Mr. George J. Rosengarten, O.C.

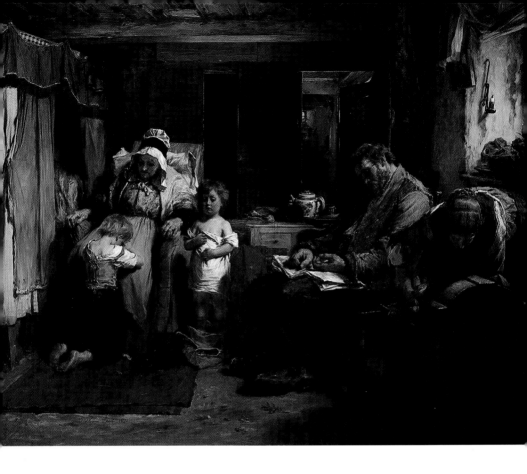

THOMAS FAED (British, 1826–1900)
When the Day is Done, 1870
oil on canvas, 118.1 x 152.4 cm
The Beaverbrook Foundation

JOHN EVERETT MILLAIS (British, 1829-1896)
James VI Taking an Affectionate Farewell of His Scottish Subjects in St. Giles'
Church Previous to His Departure to Assume the Crown of England, c.1870
ink on paper, 20.3 x 31.1 cm
Gift of Mr. George J. Rosengarten, O.C.

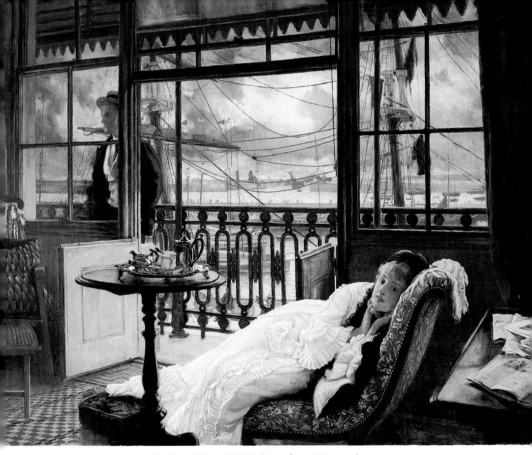

JAMES JACQUES JOSEPH TISSOT (French, 1836-1902)
A Passing Storm, 1876
oil on canvas, 76.8 x 99.7 cm
Gift of the Sir James Dunn Foundation

Facing page:
JOHN WILLIAM WATERHOUSE (British, 1849-1917)
Study for Miranda, The Tempest, date unknown
black charcoal with white highlights on paper, 47.0 x 30.8 cm
Gift of Mr. George J. Rosengarten, O.C.

HENRY TONKS (British, 1862-1937)
Hunt the Thimble, 1909
oil on canvas, 76.8 x 76.2 cm
Gift of the Second Beaverbrook Foundation

HAROLD GILMAN (British, 1876-1919)
The Verandah, Sweden, 1912
oil on canvas, 50.8 x 40.6 cm
Gift of the Second Beaverbrook Foundation

WALTER RICHARD SICKERT (British, 1860-1942)
Sunday Afternoon, c.1912-13
oil on canvas, 50.8 x 30.5 cm
The Beaverbrook Foundation

WILLIAM NEWENHAM MONTAGUE ORPEN (British, 1878-1931)
Mona Dunn, c.1915
oil on canvas, 76.8 x 63.8 cm
The Beaverbrook Canadian Foundation

AUGUSTUS EDWIN JOHN
(British, 1878-1961)
Dorelia, c.1916
oil on canvas, 212.1 x 77.2 cm
The Beaverbrook Foundation

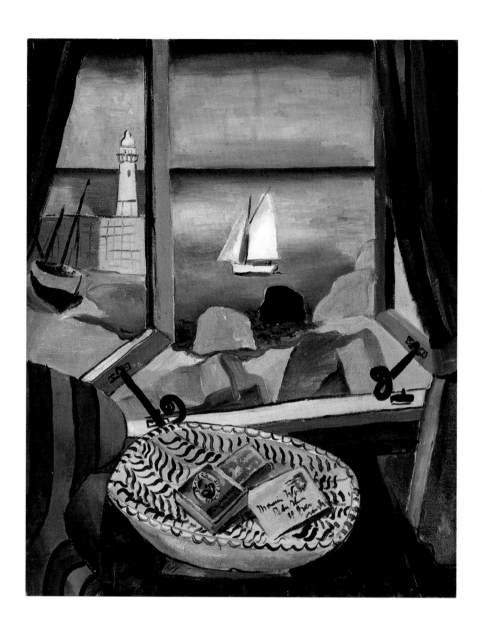

JOHN CHRISTOPHER WOOD (British, 1901–1930)
Window, St. Ives, Cornwall, 1926
oil on canvas, 76.8 x 61.0 cm
Gift of the Second Beaverbrook Foundation

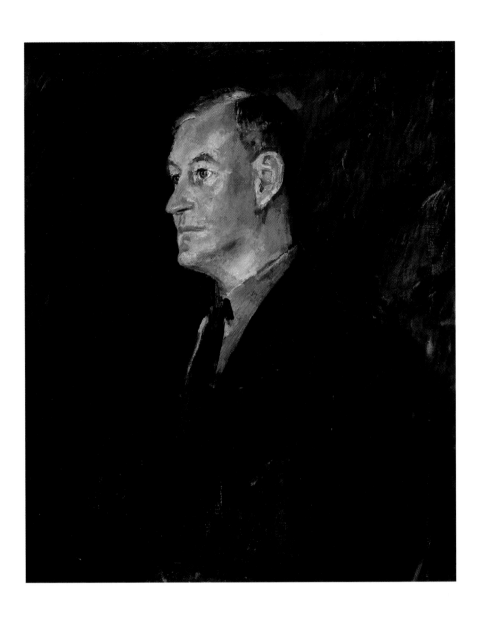

AUGUSTUS EDWIN JOHN (British, 1878-1961)
Sir James Dunn, 1929
oil on canvas, 84.5 x 69.9 cm
Gift of the Sir James Dunn Foundation

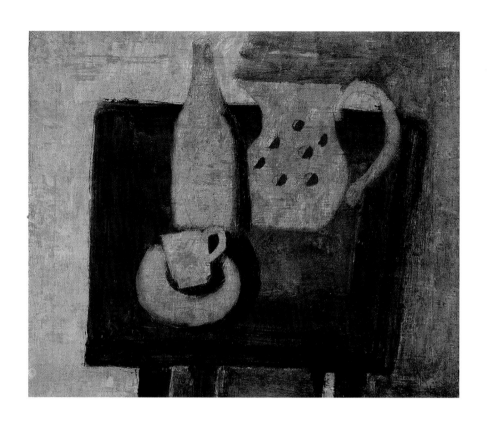

BEN NICHOLSON (British, 1894–1982)
Still Life on a Table, c.1930
oil on canvas, 51.1 x 61.0 cm
The Beaverbrook Foundation

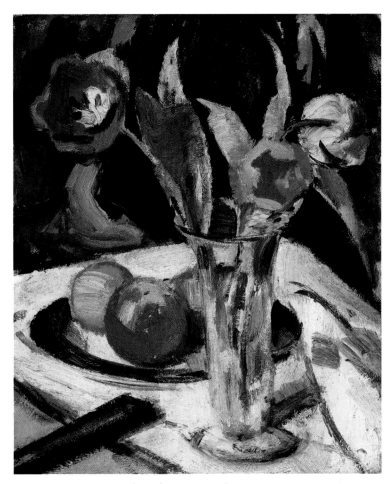

SAMUEL JOHN PEPLOE (British, 1871-1935)
Tulips and Oranges, c.1932
oil on canvas, 54.7 x 38.1 cm
Gift of the Second Beaverbrook Foundation

Facing page:
WALTER RICHARD SICKERT (British, 1860-1942)
H. M. King Edward VIII, 1936
oil on canvas, 183.5 x 92.1 cm
The Beaverbrook Canadian Foundation

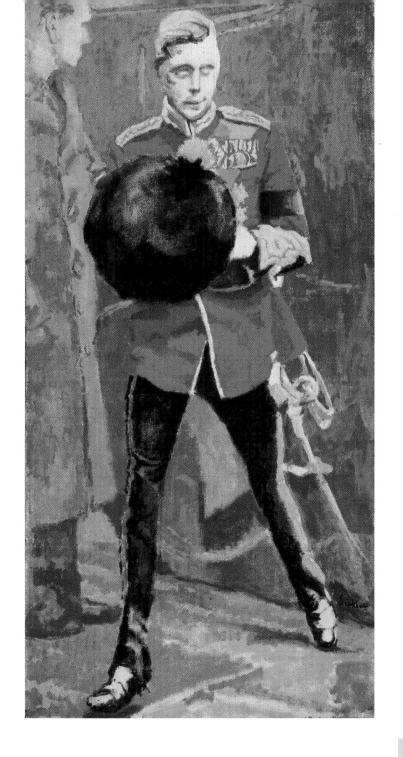

PERCY WYNDHAM LEWIS (British, 1882-1957)
The Mud Clinic, 1937
oil on canvas, 85.1 x 59.1 cm
Gift of the Second Beaverbrook Foundation

EDWARD ALEXANDER WADSWORTH (British, 1889-1949)
The Jetty, Fécamp, 1939
tempera on canvas laid down on panel, 63.8 x 89.2 cm
Gift of the Second Beaverbrook Foundation

MATTHEW ARNOLD BRACY SMITH (British, 1879-1959)
Pears with Red Background, 1947
oil on canvas, 91.4 x 71.4 cm
The Beaverbrook Foundation

THE BEAVERBROOK ART GALLERY

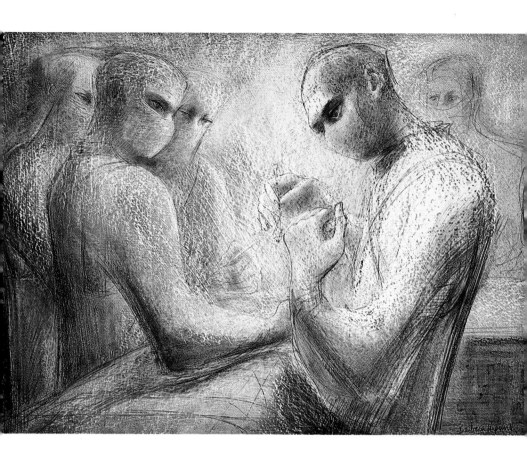

BARBARA HEPWORTH (British, 1903-1975)
The Operation: Case for Discussion, 1949
oil and pencil on pressed paperboard, 38.1 x 54.6 cm
Gift of the Second Beaverbrook Foundation

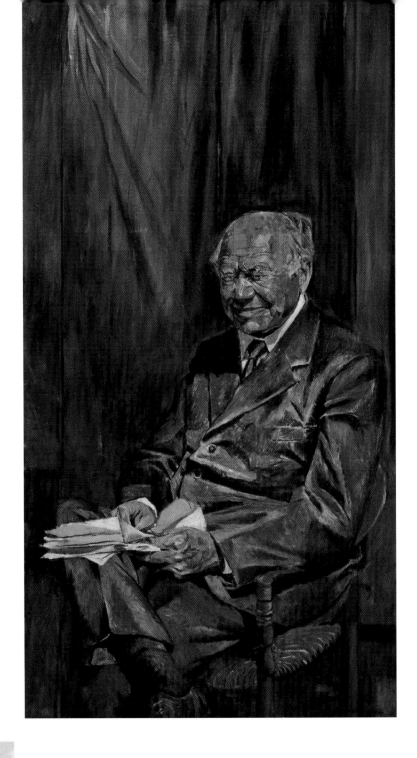

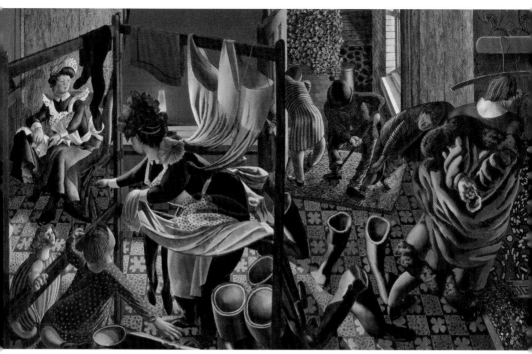

STANLEY SPENCER (British, 1891–1959)
The Marriage at Cana: A Servant in the Kitchen Announcing the Miracle,
1952–53
oil on canvas, 91.8 x 152.7 cm
Gift of the Second Beaverbrook Foundation

Facing page:
GRAHAM VIVIAN SUTHERLAND (British, 1903–1980)
Portrait of Lord Beaverbrook, 1951
oil on canvas, 174.3 x 93.4 cm
Bequest of the Dowager Lady Beaverbrook

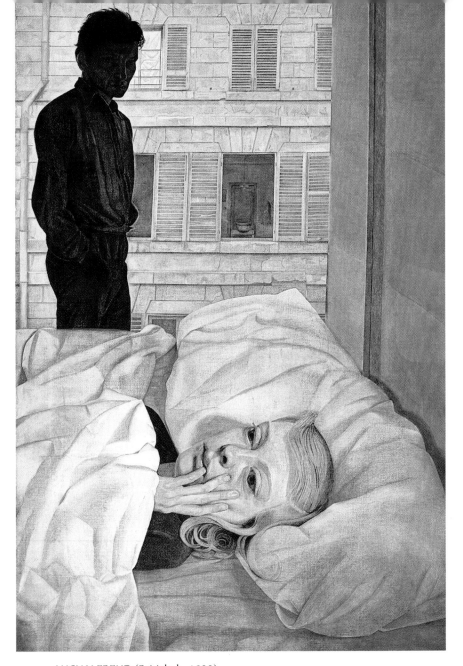

LUCIAN FREUD (British, b. 1922)
Hotel Bedroom, 1954
oil on canvas, 91.1 x 61.0 cm
The Beaverbrook Foundation

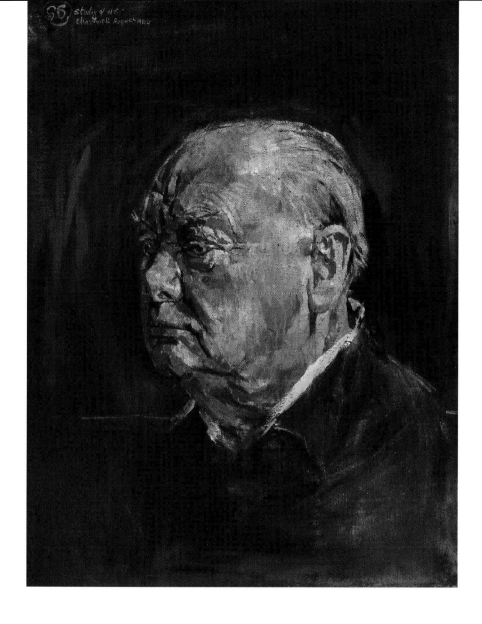

GRAHAM VIVIAN SUTHERLAND (British, 1903–1980)
Study of Churchill – Grey Background, 1954
oil on canvas, 61.0 x 45.7 cm
The Beaverbrook Foundation

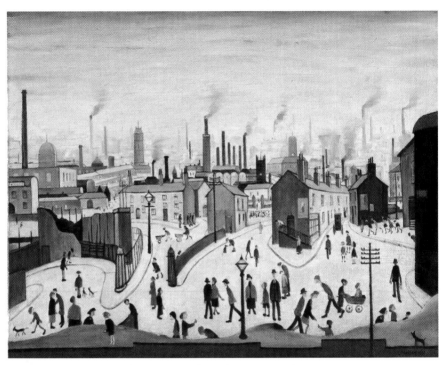

LAURENCE STEPHEN LOWRY (British, 1887-1976)
Industrial View, Lancashire, 1956
oil on canvas, 61.0 x 76.2 cm
The Beaverbrook Foundation

Facing page:
HENRY SPENCER MOORE (British, 1898-1986)
Three-quarter Figure, 1961
bronze, 1/9, height: 39.4 cm
The Beaverbrook Foundation
Reproduced by permission of the Henry Moore Foundation

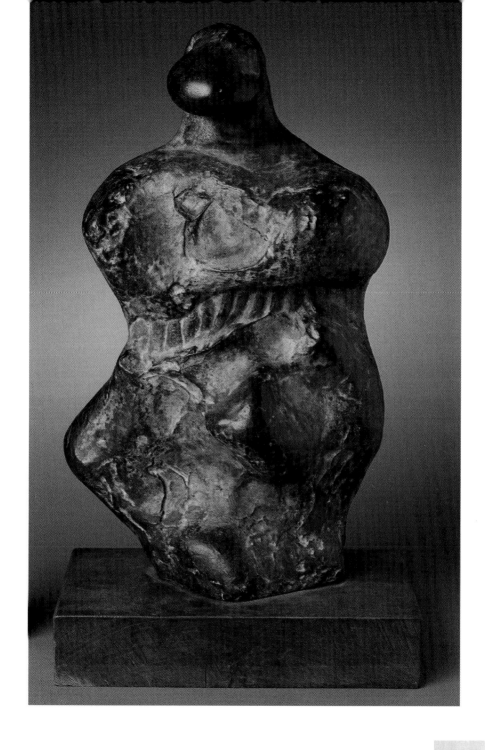

THE CANADIAN COLLECTION

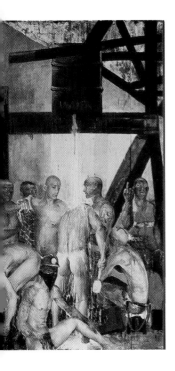
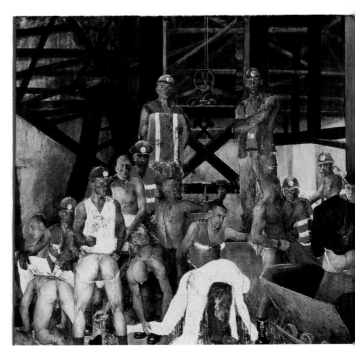

ATTILA RICHARD LUKACS (Canadian, b. 1962)
In My Father's House, 1989
oil on canvas, 398.8 x 640.0 cm
Purchased with the financial support of the Canada Council for the Arts Acquisition
Assistance Program, the Senator Richard Hatfield Fund, and anonymous donors

Curtis Joseph Collins

This discussion is intended to offer readers a context for the appreciation of the Beaverbrook Art Gallery's extensive Canadian collection, as well as a glimpse at some of those pieces which have become favourites of the institution's members and public. The development of European-style art in Canada dates back to the founding of Acadia and New France during the early seventeenth century and the establishment of British North America in the late eighteenth century. Some of the earliest images of the Maritimes were picturesque views of colonial settlements and natural land formations executed by British officers. The Beaverbrook Art Gallery holds a comprehensive collection of such works, which served military as well as artistic purposes. John Elliott Woolford, a royal engineer, architect and artist from London, first travelled to the Maritimes in 1816. He was posted to Fredericton in 1824 and served here as Assistant Barracks Master and Barracks Master General until his death in 1866. Woolford painted *View of Fredericton from the River* (107) in about 1830. This watercolour on paper serves as a colonial record of the city's principal buildings, including Market Hall with its cupola and the Officers' Barracks surrounded by trees. The figure placed in the middle ground wearing a peaked cap indicates the presence of local First Nations populations, as both Maliseet and Mi'kmaq traders supplied British government officials and troops with a variety of goods. Many British artists who chose to ply their trade in the New World trained at the Royal Academy School of London. Among them was Robert Field. Field first established himself in the Thirteen Colonies as a portrait painter, but in 1808, as tensions between America and Britain increased, he moved from Washington to Halifax. In Nova Scotia he continued to solicit

commissions from local merchants, politicians and military officers, including the oil on canvas *Portrait of John Starr*, 1813 (105), a wealthy Haligonian merchant and ship owner. This work was executed shortly before Field left for the British colony of Jamaica, where he died of yellow fever. European-trained itinerant painters were also an important source of art production in nineteenth-century Canada. Cornelius Krieghoff, a self-taught painter and musician from Holland, arrived in North America at age twenty-one and began a long career that would take him to New York, Rochester, Toronto, Quebec City and Montreal. While in Lower Canada he created numerous scenes of local life that became popular with British officers stationed in the colony as well as with resident merchants. Among the most famous works in this institution's Canadian Collection is Krieghoff's 1860 oil on canvas entitled *Merrymaking* (110), which depicts descendants of New France's settlers, known as *habitants*, exiting the inn of Jean-Baptiste Jolifou after a winter evening of revelry. Women wearing bonnets and shawls as well as men garbed in toques and Hudson Bay coats tied with *ceintures fléchées* offer present-day viewers an anecdote of rural life on the northern frontier.

Paul Kane, who emigrated from Cork, Ireland, to York (Toronto), Upper Canada, as a boy, also produced picturesque interpretations of daily life in nineteenth-century North America. Following his return from a period of study in Europe, where he made copies of paintings by sixteenth-century Italian masters, Kane decided to focus on recording First Nations communities. From 1845 to 1848 Kane made more than seven hundred drawings and watercolours of the indigenous peoples he encountered along trade routes between York and Fort Victoria on Vancouver Island. Upon returning to Upper Canada he used these studies to create works on canvas, including *West Coast Indian Encampment*, circa 1851 (109). This painting features a fishing camp of the Chinook or Flat Head people with Mount Hood in the background. Kane often grafted picturesque elements of European art

onto North American locations. In this example, the Renaissance-inspired tree in the foreground serves as a framing device for a setting from British Columbia. Similarly, Kane's Native subjects are depicted according to romantic Western notions of the unclad noble savage and thus function as exotic symbols of North America.

Following Confederation in 1867 the Dominion of Canada began to develop cultural institutions that would contribute to the building of a national identity. This included the founding in 1880 of the Royal Canadian Academy of Arts by the Governor General, the Marquess of Lorne. The academy successfully lobbied the federal government to create a national gallery in Ottawa; however, the much larger cities of Toronto, Montreal and Halifax still served as the prime locations for artistic activity in Canada. Europe was without doubt the most desirable training ground for native-born painters, who wanted to become fully versed in British and French academic traditions. The Beaverbrook Art Gallery has a wide selection of late-nineteenth- and early-twentieth-century paintings by Canadian artists who were inspired by or gained instruction from the schools of Paris and London. Maurice Galbraith Cullen, who was born in St. John's, Newfoundland, and raised in Montreal, ventured to the French capital in 1888 like many North American artists, to train at the prestigious École des Beaux-Arts. Upon his return to Canada he created numerous winter scenes of urban and rural Quebec, that were exhibited at the annual Royal Canadian Academy of Arts and the Art Association of Montreal shows. Cullen applies tiny dabs of complementary-coloured paints to canvas in *St. James Cathedral, Dominion Sq., Montreal*, circa 1910 (114) creating atmospheric effects deriving from Impressionism.

Clarence Alphonse Gagnon also studied in the Paris at the studio of the academician Jean-Paul Laurens. Upon his return to Canada in 1909 he divided his time between Baie St-Paul and Montreal, while maintaining a studio in Paris. The oil on panel *Mid Winter Morning: Baie St. Paul*, 1920 (120) is typical of Gagnon's work, which depicts

villages and farms in the Saint Lawrence Valley that are similar to the French painter Paul Gaugin's scenes of agricultural communities in Brittany. Images of churches and wayside crosses, common in Gagnon's work, signified the Catholic church's central role in Quebec society for over three hundred years. By 1923 Gagnon had been elected an associate of the Royal Canadian Academy of Arts, and in 1933 he received a commission to illustrate the French-born author Louis Hémon's book *Maria Chapdelaine*. The painter was well suited for this task. His work, like the immensely popular novel, extolled the simple virtues of peasant life and the strong links between the *habitants* and the church. Such rural narratives of Quebec were particularly popular with collectors in the urban centres of Canada, France and England.

The hegemony of European art and its influence on Canadian art practices at the turn of the century served as a catalyst of reaction for the Toronto painters known as the Group of Seven. This collective was founded in 1920 by Franklin Carmichael, Lawren Harris, A.Y. Jackson, Franz Johnston, Arthur Lismer, F.H. Varley and J.E.H. MacDonald. The goal of these self-proclaimed modernists was to produce a nationalistic art free of foreign influences. MacDonald emigrated with his family from Durham, England to Hamilton, Ontario at the age of fourteen and studied at the Hamilton Art School. After moving to Toronto he worked as a graphic designer and took evening art classes at the Ontario School of Art and Design. Many of the wooded areas in and around Toronto, including High Park, the Humber Valley and Thornhill, where he owned a farm, served as subject matter for his early work. The thick paint and bold outlines of MacDonald's *Evening, Thornhill*, circa 1914 (117) would soon become a trademark of the emerging group, whose members eventually travelled to Northern Ontario, Quebec's Eastern Townships and the Rocky Mountains to paint landscapes void of humans or animals. During the 1920s and 1930s their art was championed by

Eric Brown, the National Gallery of Canada's first director, who organized cross-country as well as international exhibitions for the Toronto-based collective. Brown was also instrumental in promoting the Victoria-born painter Emily Carr. Carr studied art at the California School of Design in San Francisco and later exhibited with the Group of Seven. However, Carr's paintings, unlike those of the Toronto group, often featured human figures, more specifically the aboriginal communities of Vancouver Island. *Indian Village: Alert Bay*, circa 1912 (116) is a fine example of the manner in which she deftly rendered indigenous North American art forms such as the totem pole. The towering pine trees in the background rendered as flat areas of pure colour were also a common feature of her work, that had gained widespread public recognition by the 1930s. Over the past seventy years, the paintings of Carr and the Group of Seven have achieved icon-like status, and their respective conceptions of the Canadian wilderness continue to function as national symbols.

Canada's military contribution to the First and Second World Wars played a critical role in establishing this country's identity as a sovereign state, as well as a middle power among Western nations. In 1916, Lord Beaverbrook and Lord Rothermere, recognizing the potential cultural impact of the Great War, established the Canadian War Memorials Fund. It was used to commission artists, including F.H. Varley and A.Y. Jackson, to portray Canada's war effort. In 1943, during the Second World War, Canada's High Commissioner to Britain, Vincent Massey, and the National Gallery of Canada's director, H.O. McCurry, followed Beaverbrook's lead and created the War Art Program. Artists serving in the Canadian armed forces at locations across Europe, North Africa, Canada and the Alaskan coast, as well as in the Atlantic and Pacific Oceans, produced over one thousand works of art. Miller Gore Brittain, who was born in Saint John, New Brunswick, and studied in New York at the Art Students League, served as a bomb-aimer for the Royal Canadian Air Force and then as

an official war artist from 1945 to 1946. This celebrated New Brunswick artist, best known for his social realist paintings featuring Saint John's working class, created *Dying Soldier* (126) in 1947, shortly after returning to Canada. Most of Brittain's war art consists of drawings that delve into the psychological impact of death, and his intricate web of pastel lines on paper reveals the pain on an anonymous serviceman's face moments before his last breath.

The Second World War also precipitated a considerable change in the international art market, as numerous artists as well as dealers moved from Paris to New York. As a result, from the mid-1940s onward Canadian painters increasingly looked to America's largest city as a primary source of avant-garde ideas. Radical artist collectives, including *les automatistes* in Montreal and the Painters Eleven in Toronto, experimented with non- objective methods of creativity that were consistent with New York movements such as Action Painting and Post-Painterly Abstraction. Montreal-born artist Jean-Paul Riopelle was a member of *les automatistes* and a signatory of the 1948 manifesto *Refus Global*, which called for a new cultural consciousness in Quebec and ultimately led to the Quiet Revolution of the 1960s. However, from 1946 onward Riopelle resided in Paris, where he became a central figure on the international art circuit, receiving the UNESCO award for cumulative achievement in 1962. *Canadian Ballet*, 1958 (128) features areas of bold-coloured oil paint built up on the surface of the canvas with a palette knife. These frenzied strokes are a result of the artist's reliance on subconscious impulses to direct his creative act, and such art was supposed to function as a visual graph of its creator's mind. Riopelle's methods were closely linked to the doctrines of Surrealism established by André Breton, a Parisian writer, poet and artist who championed automatic painting as well as dream imagery in the 1930s, 1940s and 1950s.

By the early 1960s artists in smaller urban centres had also begun to explore non-objective painting methods. In Regina, the University

of Saskatchewan School of Art organized the Emma Lake Workshops, which engaged New York artists such as Barnett Newman and critics such as Clement Greenberg. The participation of these Americans had a profound effect on the Regina art scene. The work of one group of local painters and teachers, the Regina Five, reflected an attention to materials and process that was guided by non-representational concerns. This collective, which included Kenneth Lochhead, Douglas Morton, Ted Godwin, Ronald Bloore and Arthur McKay, first gained notoriety in 1961 when the National Gallery of Canada presented a travelling exhibition of their work. Arthur Fortescue McKay was born in Nipawin, Saskatchewan. He studied at the Provincial Institute of Technology and Art in Calgary, the Académie de la Grande Chaumière in Paris, and the Barnes Foundation in Merion, Pennsylvania. McKay first became involved with the group of artists associated with the University of Saskatchewan during the early 1950s. By 1964 he had been appointed the director of the School of Art. His *Image of a Green Presence*, 1968 (130) features a brown ovoid form floating on a flat green textured background. Work such as McKay's eschews the long-standing Western tradition of painting as a medium for creating illusory spaces that convey shared narratives of human existence. Post-war modernist painters in Canada used the surfaces of their huge canvases or boards to create individual motifs not unlike corporate logos. This relatively new tradition is well represented in the gallery's collection.

The impact of non-objective painting that prevailed in artistic communities across North America during the 1960s and 1970s did not gain much of a foothold in Eastern Canada. Many artists in the Maritimes remained committed to the advancement of landscape and figurative painting. Such artists included Molly Lamb Bobak, who moved to Fredericton with her husband, fellow artist Bruno Bobak, in 1959. Molly Lamb was born in Vancouver in 1920, and studied at the Vancouver School of Art. In 1945 she was appointed a war artist, and

upon her return from Europe worked as an art instructor at the Vancouver Art Gallery during the 1950s. Since settling in New Brunswick she has painted many local events and sites, including *Beach*, 1972 (133), which depicts sunbathers and swimmers on Shediac Bay in the Northumberland Strait. Bobak has become famous for such crowd scenes, in which people and objects lack detail and are rendered in bright colours that produce busy surface effects.

In 1957 the federal government established the Canada Council for the Arts. The council, a Crown Corporation that does not report directly to government, was created to provide financial assistance to artists and arts organizations, both to support the arts and to protect the sovereignty of Canada's cultural industries from American domination. This bold cultural directive resulted from a Royal Commission on National Development in the Arts, Letters and Sciences headed by the future Governor General, Vincent Massey. Over the past twenty years the programs of this arm's-length agency have fostered an incredible growth and diversification in the visual arts. Sculpture, photography, installation and performance art have gained a national profile that had previously been reserved for painting only. Halifax artist John Greer has played a critical role in the development of contemporary sculpture in Canada as an artist and teacher. Greer studied at the Nova Scotia College of Art and Design, the Montreal Museum School of Art and Design, and the Vancouver School of Art. In 1978, he began teaching at the Nova Scotia School of Art and Design, an institution that has nurtured conceptual art in Canada since the 1960s. In 1991, Greer secured a Canada Council grant to undertake an artist's residency in Italy. During his stay abroad he created *Nine Grains of Rice* (138) using marble extracted from an ancient quarry in Carrara. These giant grains of rice carved from white stone have been exhibited on gallery floors in Fredericton, Toronto, Ottawa and Florenceville, New Brunswick. Their oversized scale and unique placement evoke a unique bodily relationship between the

viewer and the art object. The commonly used metaphor of rice as a grain of knowledge coupled with the foodstuff's role as a staple of human nourishment contribute to the potential for numerous and layered interpretations of Greer's work.

Personal history, gender issues and social situations are major influences on contemporary art in Canada, and the Beaverbrook Art Gallery's collection is beginning to reflect their impact. Montreal artist Geneviève Cadieux, who studied visual arts at the University of Ottawa, has in the past decade become one of this country's most celebrated international artists. Cadieux's *Rubis*, 1993 (139) is a colour photograph of Cadieux's mother positioned beside a blown-up microscopic view of human blood cells. Perhaps the most predictable association that one could make between these two images is that of an infected elderly person. Such an observation relates to the dark ring around one of the cells and contemporary society's heightened sense of awareness of the often outwardly invisible conditions of diseases including cancer. However, this plausible visual connection would be incorrect, as the artist avoids obvious narratives and yet plays with their existence. Her combination of these seemingly disparate images is more closely related to the work's title, *Rubis* (Ruby), which equates the colour as well as the texture of the dark red blood cells with the beauty marks on her mother's back.

During the 1980s and 1990s, the mass media generated countless real and simulated scenes of violence and sex, and artists including Attila Richard Lukacs reinvigorated painting through an investigation of the ambiguous moral boundaries around such subjects. Lukacs was born in Edmonton and studied at the Emily Carr College of Art and Design in Vancouver. In 1986 he moved to Berlin, where he painted the *E-werk* series of murals. One of the murals, *In My Father's House,* 1989 (94) features various groupings of men in a mining scene. However, their clothing, shaved heads and tattoos identify them as members of Germany's various skinhead subcultures. A few of the

semi-nude males strike seemingly homoerotic poses, while others make obscene as well as fascist hand gestures at the viewer. Lukacs's coyly suggestive imagery provokes the ability of cultural institutions in Canada, including the Beaverbrook Art Gallery, to display art that challenges social and political norms.

Current artistic practices are changing the nature of art collecting. Conceptual, photographic, video, computer and installation arts demand that galleries find new ways to save and retrieve aesthetic experiences. The Beaverbrook Art Gallery is responding to this challenge. At the beginning of 2000, Moncton-born artist Paul Édouard Bourque created a painting-installation for the gallery's Marion McCain Atlantic Gallery. The work, entitled *Plexus* (144), featured a variety of materials, including watercolours, copy toner, Styrofoam, fabric, acrylics, wood and plastic applied directly to the walls. Bourque, a graduate of the University of Moncton and an active member of New Brunswick's Acadian cultural community, assembled the work during a two-week residency in Fredericton. The installation surrounded viewers entering the space with a story of a man from birth to death. Before the installation was dismantled, a section of the work was retained as an archival record of the show. This fragment, which is now part of the gallery's permanent collection, reflects an ongoing commitment to Lord Beaverbrook's original philanthropic goal: "The main purpose of this gallery is to inspire Canadian artists of the new generation."

ROBERT FIELD (British, c.1769-1819)
Portrait of John Starr, 1813
oil on canvas, 76.2 x 63.7 cm
Purchased with funds from the Senator Richard Hatfield Memorial Fund

ANONYMOUS "M" (Canadian)
View of Fredericton, 1823
oil on canvas, 48.3 x 68.6 cm
Gift of Canada Steamship Lines Ltd., in memory of Sir James Dunn, Bart.

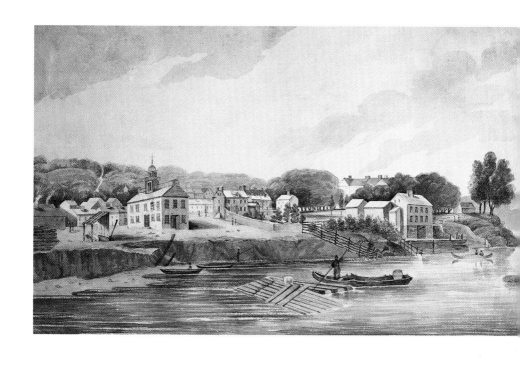

JOHN ELLIOTT WOOLFORD (British, 1778-1866)
View of Fredericton from the River, c.1830
watercolour on paper, 25.4 x 40.6 cm
Purchased with funds from Mrs. A. Murray Vaughan

WILLIAM ROBERT HERRIES (Canadian, 1818-1845)
Quebec in the Winter and a Toboggan Sleigh, c.1838
watercolour on paper, 22.9 x 34.6 cm
Purchased with a Minister of Communications Cultural Property Grant and funds
from the Marguerite and Murray Vaughan Foundation and the Samuel Endowment

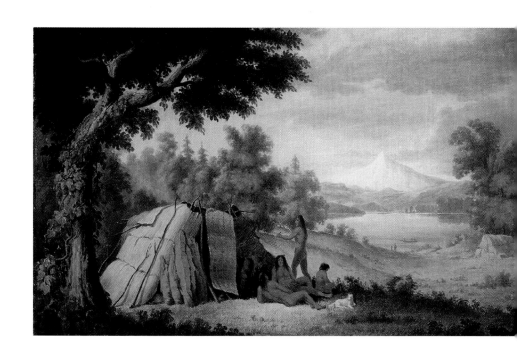

PAUL KANE (Canadian, 1810-1871)
West Coast Indian Encampment, c.1851
oil on canvas, 43.2 x 71.1 cm
Gift of Lord Beaverbrook

CORNELIUS KRIEGHOFF (Canadian, 1815-1872)
Merrymaking, 1860
oil on canvas, 88.9 x 121.9 cm
The Beaverbrook Canadian Foundation

JOHN ARTHUR FRASER (Canadian, 1838-1898)
The Sun's Last Kiss on the Crest of Mount Stephen, from "Field," Rocky
Mountains, B.C., 1886
watercolour on pressed paperboard, 44.5 x 63.5 cm
The Beaverbrook Canadian Foundation

HORATIO WALKER (Canadian, 1858-1938)
The First Snow, 1908
oil on canvas, 61.6 x 84.5 cm
Gift of the Second Beaverbrook Foundation

Facing page:
WILLIAM BRYMNER (Canadian, 1855-1925)
The Citadel: Quebec, 1909
oil on canvas laid down on pressed paperboard, 51.8 x 33.7 cm
Gift of the Second Beaverbrook Foundation

MAURICE GALBRAITH CULLEN (Canadian, 1866-1934)
St. James Cathedral, Dominion Sq., Montreal, c.1909-12
oil on canvas, 76.8 x 102.2 cm
Gift of Miss Olive Hosmer

JAMES WILSON MORRICE (Canadian, 1865-1924)
Concarneau Cirque, c.1910
oil on canvas, 60.6 x 81.3 cm
The Beaverbrook Canadian Foundation

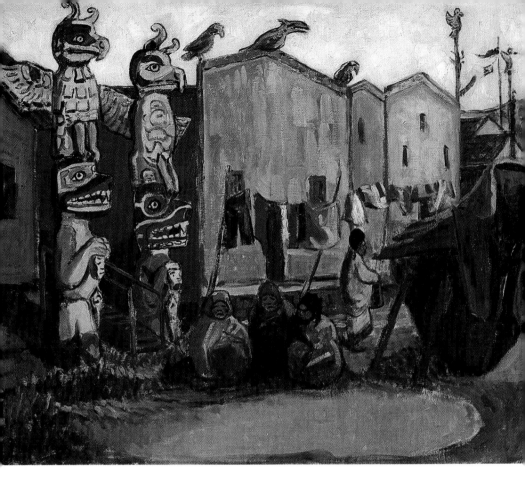

EMILY CARR (Canadian, 1871-1945)
Indian Village: Alert Bay, c.1912
oil on canvas, 63.5 x 81.3 cm
Gift of Lord Beaverbrook

JAMES EDWARD HERVEY MacDONALD (Canadian, 1873-1932)
Evening, Thornhill, c.1914
oil on beaverboard, 71.8 x 92.1 cm
Gift of the Second Beaverbrook Foundation

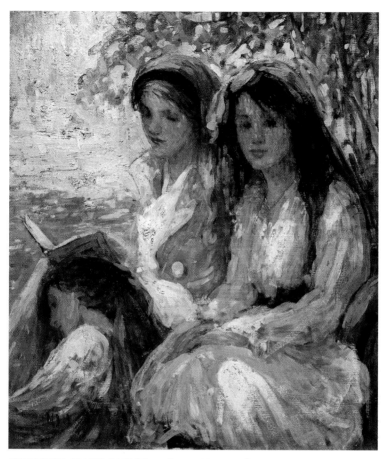

HENRIETTA MABEL MAY (Canadian, 1884-1971)
Three Sisters, c.1915
oil on canvas, 77.2 x 67.3 cm
Gift of Lord Beaverbrook

Facing page:
TOM THOMSON (Canadian, 1877-1917)
Spring, c.1915
oil on canvas, 101.6 x 63.5 cm
Gift of Lord Beaverbrook

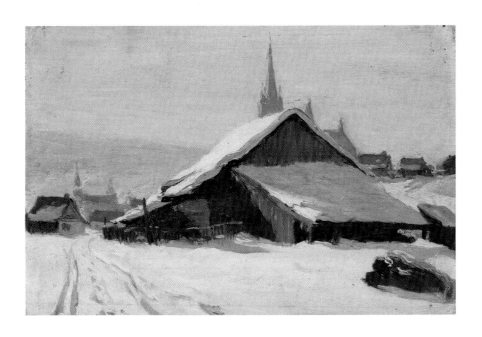

CLARENCE ALPHONSE GAGNON (Canadian, 1881-1942)
Mid Winter Morning: Baie St. Paul, 1920
oil on panel, 15.6 x 23.5 cm
Gift of Mrs. Eric Phillips

LAWREN STEWART HARRIS (Canadian, 1885-1970)
Morning, c.1921
oil on canvas, 97.2 x 112.4 cm
Gift of the W. Garfield Weston Foundation

JACK WELDON HUMPHREY (Canadian, 1901-1967)
The White Pitcher, 1930
oil on canvas, 94.5 x 72.1 cm
Gift of the Second Beaverbrook Foundation

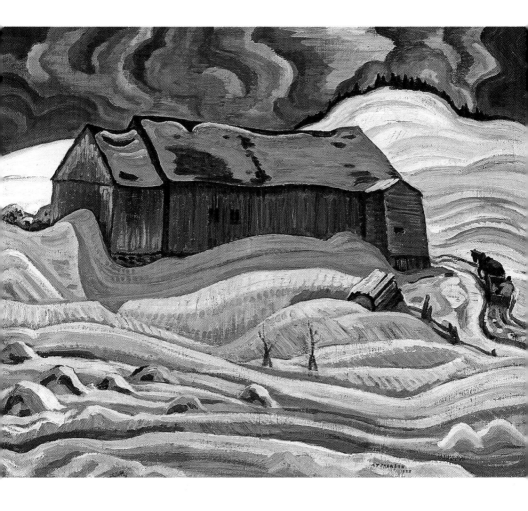

ALEXANDER YOUNG JACKSON (Canadian, 1882-1974)
Grey Day, Les Éboulements, 1935
oil on canvas, 63.5 x 81.3 cm
Purchased with the assistance of the Canadian Cultural Property Export Review
Board, the Harrison McCain children, the Dynamic Fund Foundation and the
Beaverbrook Foundation

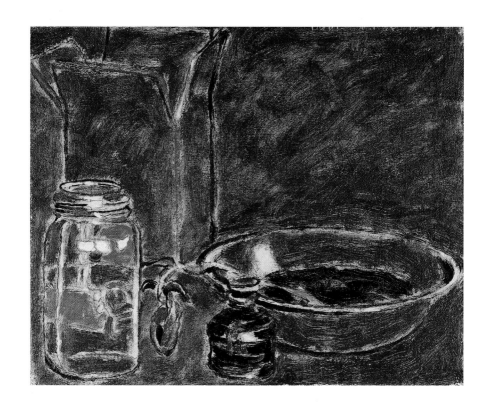

DAVID MILNE (Canadian, 1882–1953)
Mocassin Flower, 1935
oil on canvas, 46.3 x 56.5 cm
Gift of David H.M. Vaughan and Lucinda Flemer, Executors of the Estate
of the late L. Marguerite Vaughan

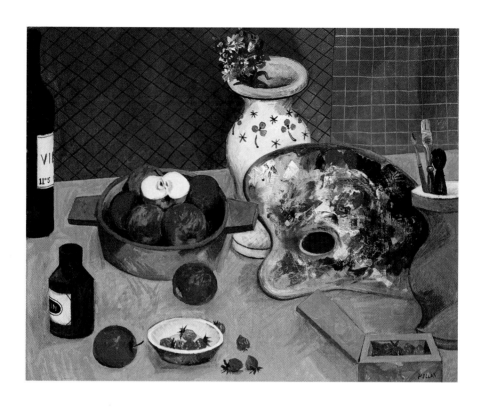

ALFRED PELLAN (Canadian, 1906-1988)
Nature morte à la palette, 1940
oil on canvas, 64.8 x 80.7 cm
Gift of Lord Beaverbrook

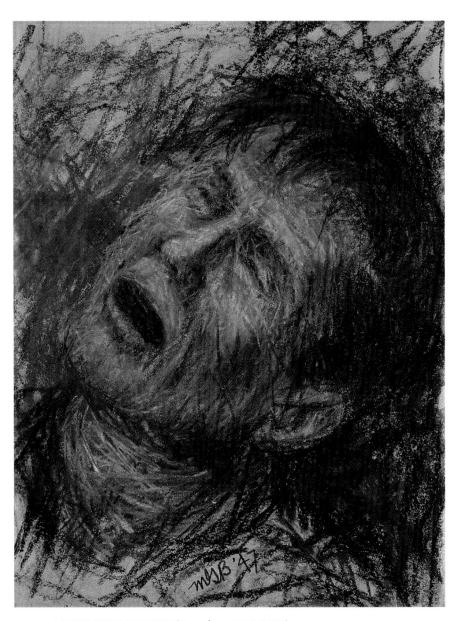

MILLER GORE BRITTAIN (Canadian, 1912-1968)
Dying Soldier, 1947
pastel on brown paper, 59.4 x 38.2 cm
Bequest of Dr. Paul Toomik

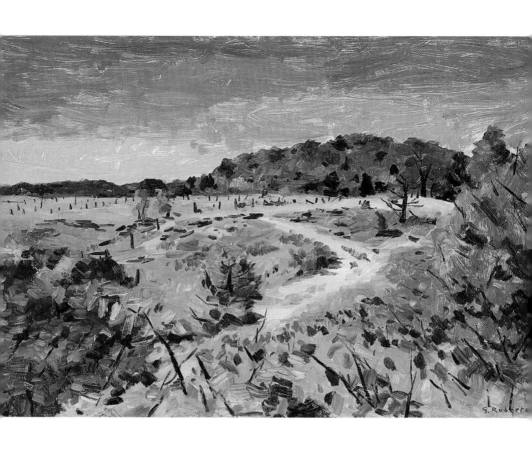

GOODRIDGE ROBERTS (Canadian, 1904-1974)
Autumn Landscape, 1956
oil on masonite, 61.0 x 91.4 cm
Gift of Celanese Canada Inc.

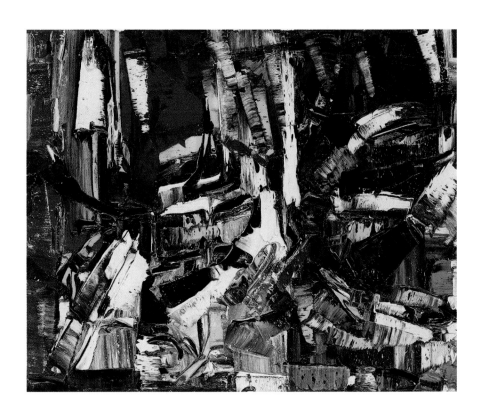

JEAN-PAUL RIOPELLE (Canadian, b. 1923)
Canadian Ballet, 1958
oil on canvas, 49.8 x 61.0 cm
Gift of Mr. Arpad Plesch
© Jean-Paul Riopelle / SODRAC (Montreal) 2000

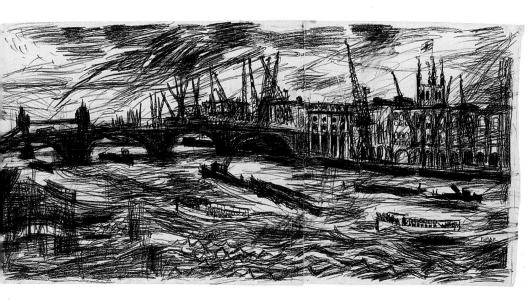

BRUNO BOBAK (Canadian, b. 1923)
The Thames (Pool of London), 1963
conté on two sheets of Ingres paper, 47.0 x 101.0 cm
Gift of the artist

ARTHUR FORTESCUE McKAY (Canadian, 1926-2000)
Image of a Green Presence , 1968
oil on masonite, 121.9 x 243.8 cm
Purchased with funds from the Canada Council for the Arts Director's Choice
Programme and the Beaverbrook Art Gallery

GUIDO MOLINARI (Canadian, b. 1933)
Bi-sérial bleu-orange, 1968
acrylic on canvas, 205.7 x 365.8 cm
Purchased with a grant from the Gelmont Foundation Fine Arts Acquisition Programme

JACK BUSH (Canadian, 1909-1977)
Triple, 1971
acrylic on canvas, 167.6 x 335.3 cm
Purchased with funds from a Minister of Communications Cultural Property Grant
and the General Purchase Fund
© Estate of Jack Bush

MOLLY LAMB BOBAK (Canadian, b. 1920)
Beach, 1972
oil on masonite, 101.6 x 121.9 cm
Purchased with funds from the Beaverbrook Canadian Foundation for the
Wallace S. Bird Memorial Collection

GREG CURNOE (Canadian, 1936-1992)
Doc Morton Front Wheel, 1980
serigraph on Plexiglas, 63/65
72.1 x 71.0 cm
Purchased with funds from the Senator Richard Hatfield Memorial Fund
© Estate of Greg Curnoe / SODRAC (Montréal) 2000

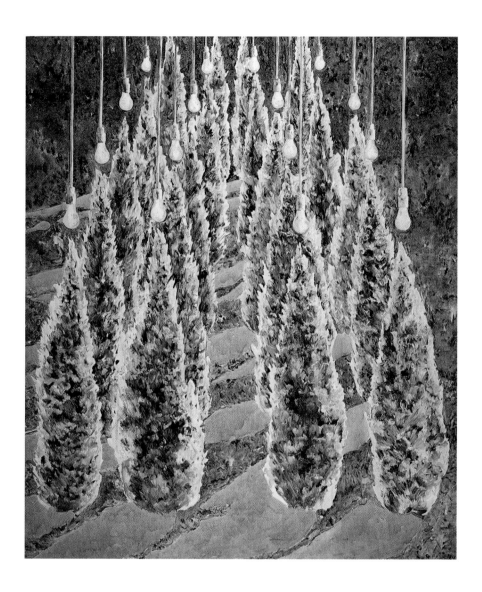

GATHIE FALK (Canadian, b. 1928)
Boulevard Trees & Lights, 1984
oil on canvas, 200.0 x 169.6 cm
Donated to the Beaverbrook Art Gallery by the American Friends of Canada
Committee, Inc., through the generosity of Mr. Edward L.C.Haslam

THE CANADIAN COLLECTION

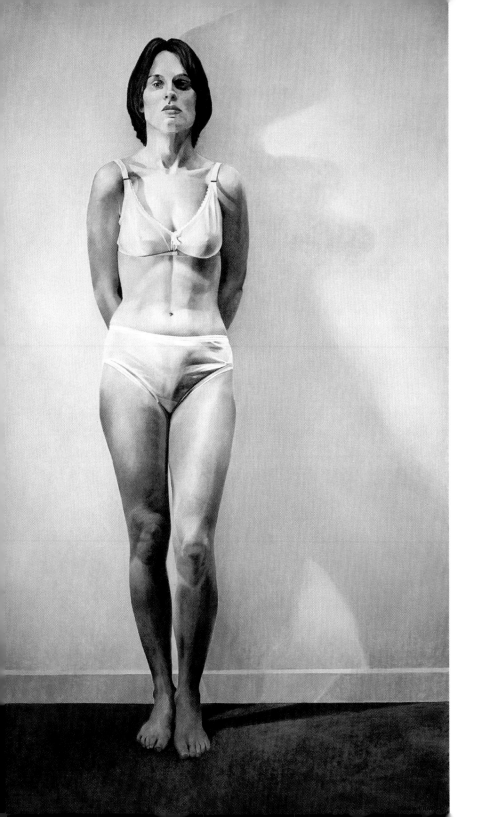

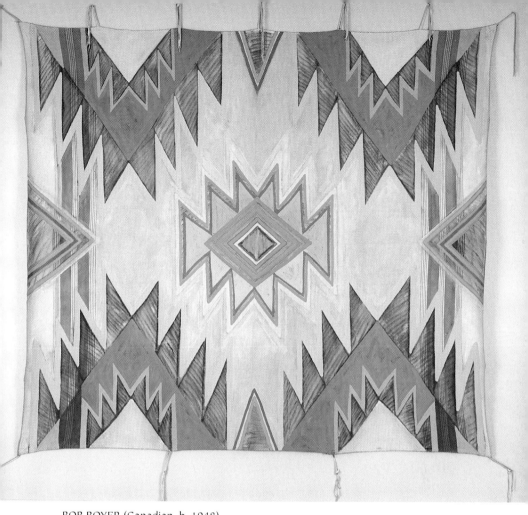

BOB BOYER (Canadian, b. 1948)
For All My Relations, 1989
oil over acrylic and mixed media, 200.0 x 227.3 cm
Purchased with funds from the Canada Council for the Arts Special Purchase
Assistance Programme

Facing page:
MARY PRATT (Canadian, b. 1935)
This is Donna, 1987
oil on canvas, 188.0 x 106.7 cm
Gift of Jim Coutts in memory of Marion McCain

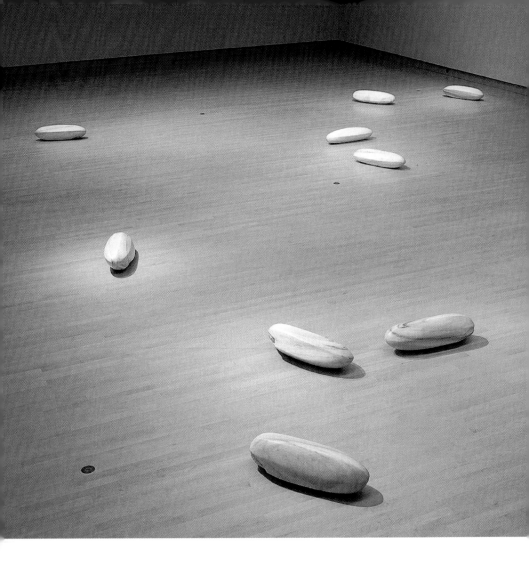

JOHN GREER (Canadian, b. 1944)
Nine Grains of Rice, 1991
marble, each: 162.6 x 50.8 x 27.9 cm
Purchased with funds from the Senator Richard Hatfield Memorial Fund and the
Canada Council for the Arts Acquisition Assistance Programme

GENEVIÈVE CADIEUX (Canadian, b. 1955)
Rubis, 1993
colour photograph on Plexiglas, 2/2, 268.6 x 358.8 cm
Purchased with funds from the Senator Richard Hatfield Memorial Fund
and the Canada Council for the Arts Acquisition Assistance Programme

CHRISTOPHER PRATT (Canadian, b. 1935)
Big Cigarette, 1993
oil on canvas, 77.2 x 132.7 cm
Gift of Harrison McCain, C.C.

DAVID ALEXANDER COLVILLE (Canadian, b. 1920)
Embarkation, 1994
acrylic polymer emulsion on Panfibre wood particle board, 47.5 x 74.2 cm
Gift of Harrison McCain, C.C.

SARAH MALONEY (Canadian, b. 1965)
Shoe Forms, 1996
wooden shoe forms, acrylic and ink, 10.0 x 10.0 x 30.0 cm
Gloves, 1996
kid gloves and ink on antique table, 42.0 x 36.0 cm
Sleeve Board, 1996 (not shown)
wooden sleeve board, acrylic and ink, 168.0 x 13.0 x 36.0 cm
Knitted Arms, 1997
antique dressmaker's armature, knitted cotton string, 168.0 x 46.0 x 36.0 cm
Purchased with funds from the Senator Richard Hatfield Memorial Fund

ROBIN COLLYER (Canadian, b. 1949)
Field, 1997
colour photograph on photographic paper, 1/1, 76.2 x 101.6 cm
Gift of Mark, Ann, Laura and Gillian McCain in memory of their brother, Peter
McCain

PAUL ÉDOUARD BOURQUE (Canadian, b. 1956)
Plexus, installation fragment, 2000
mixed media, 122.0 x 488.0 cm
Gift of the artist

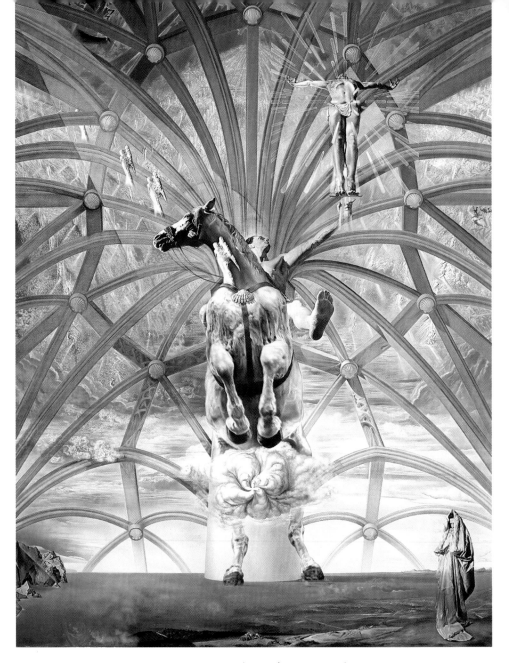

SALVADOR FELIPE JACINTO DALI (Spanish, 1904-1989)
Santiago El Grande, 1957
oil on canvas, 407.7 x 304.8 cm
Gift of the Sir James Dunn Foundation

Laurie Glenn

The Beaverbrook Art Gallery's international collection spans six hundred years of artistic practice in Western Europe. It includes works created between 1340 and 1957 and offers both the general viewer and the scholar a wide-ranging yet cohesive array of art history's most familiar subjects. The collection can be divided broadly into two categories, sacred (Christian) art and profane (secular) art, which have historically been regarded as diametrically opposed but which have always been produced simultaneously and often contain similar imagery. Sacred themes were common in Western art from the first century C.E. until the nineteenth century, when this type of art became undermined by an increasingly secularized and industrialized world view. Sacred art describes the heavenly realm, life after death and the power of God. It consists of moralizing images and narratives of the holy Christian family, in particular the lives of Jesus and his mother, the Virgin Mary, and stories from the lives of the saints. Profane art focuses upon the earthly realm and its day-to-day concerns, love, death and pagan mythology. The human figure is reproduced extensively in both sacred and profane art. It appears most often in portraits, but is also found in works that idealize the human form (usually female), and in those that tell a story.

The earliest example of sacred art in the gallery's collection is *Christ on the Cross and Virgin and Child Between Two Angels* (154). This ivory diptych, created about 1340 by an anonymous artist of the German School, portrays Christ's Nativity and Crucifixion. Its small size and portability suggest that it was used for personal devotions.

The culmination of the story of Jesus is portrayed in a painting by

Sandro Botticelli, *The Resurrection*, circa 1490 (156). The tip-tilted head and elongated limbs, hands and feet, were artistic conventions frequently employed by Botticelli. Christ's head is adorned with a red and gold halo to symbolize both his martyrdom and his divinity. He carries a white banner decorated with a red cross, a symbol of his victory over death.

Mary is often represented in one of two types of formal groupings: the *sacra conversazione*, in which saints surround the Virgin and Child; or the holy kinship, which depicts the pair with Mary's family members and ancestors. The anonymous German painting *Virgo inter Virgines* (The Virgin Surrounded by Saints), circa 1470 (155) is an example of both. In the painting, Mary's mother, Saint Anne, thirteen female saints and a number of musicians attend Mary and Jesus. This work is one of the earliest-known representations of the holy kinship theme.

In addition to Mary, historical female figures and women from Greek and Roman mythology were often painted as didactic images for women to study and emulate. The story of Lucretia, a Roman woman of great virtue and chastity, was popular in Europe during the sixteenth century. The wife of a high-ranking military official, Lucretia was raped by a nobleman. In order to clear her name and to set an example of female chastity and sacrifice, she killed herself with a dagger. Lucretia was usually portrayed holding a knife in her hand, moments before her suicide, and in spite of her reputation as a woman of virtue, she was often painted in scanty clothing. Her body served as a model for the idealized female figure, and as such her image would have hung in the private chambers of many a European nobleman. The original panel of the gallery's *Lucretia* (158), painted by the German artist Lucas Cranach the Elder, in about 1530, was a full-length piece. It was cut down to just below the breasts of the figure, and the tip of the knife can barely be discerned at the bottom of the panel. This alteration dramatically changed the meaning of the work.

Lucretia's identity was lost, and the painting became merely a study of female physical beauty and erotic suggestiveness.

Since antiquity, portraiture had been an important means of identification and propaganda. During the sixteenth century, portraits of aristocratic men were produced to display their social position and intellectual, political or military prowess. Two such portraits are found in the gallery's collection. In around 1540 the French artist and engraver Corneille de Lyon painted *Claude de Clermont-Tonnerre, Sieur de Dampierre* (160). De Lyon was a painter of the French court; his subjects included Kings Francis I and Henri II and Queen Catherine de Medici. He is considered to be one of the most important French portrait painters of his time. The provenance of the Clermont portrait can be traced back to the mid-eighteenth-century art collection of the English politician and writer Horace Walpole. The funerary decorations on the frame (the putti, hourglass and skull) suggest that it was likely added after Clermont's death in 1545. The second work, *André Reidmor* (159), is a half-length, three-quarter portrait of a well-dressed German burgher, painted in 1540 by Bartholomäus Bruyn the Elder. Art historian James Collier described it in 1986 as being "among the finest examples . . . of Bruyn's portraits." The work is one of three Bruyn paintings owned by the gallery

Secular art often adorned items found in the homes of wealthy Europeans. The gallery owns three Italian *cassoni,* or wooden storage chests. The *Cassone with Pedestal* (157), made some time during the 1500s, is decorated with putti holding a garland of flowers and female muses at its front corners. The families of wealthy patricians, bankers and merchants owned *cassoni,* which were usually given as wedding gifts, serving first as display pieces in marriage processions, then as luxury items in the newlyweds' homes. They were often ornately carved, gilded and painted with elaborate multi-figured scenes related to marriage and fertility. While used for the storage of clothing and

linens, the *cassoni* would have been part of the home's interior decoration.

The fabric arts also contributed domestic items that were both functional and decorative. The tapestry entitled *The Hunts of Maximilian, July (The Report)* (161) fulfilled both these purposes. The tapestry is one of a set of twelve created by Jean Baptiste Mozin between 1691 and 1693 in the Gobelins Tapestry Workshop in France. It depicts a hunting party led by German king and Holy Roman Emperor Maximilian I (d. 1519). The tapestry was created from designs by artist Barend van Orley and is one of the third set of copies, or editions, of the tapestries to be produced. In all, nine editions were created. These tapestries depict Maximilian's yearly cycle of hunting activities in much the same way that a book of hours, a yearly calendar popular during the fifteenth century, displayed religious and secular activities in a contemporary setting. The month of July shows the hunters assembled in a wood, being updated on the location of their quarry, in this case a wild boar.

Historical narratives also decorate a pair of porcelain fruit coolers produced in the Barr, Flight, Barr Worcester Porcelain Works of Worcester, England, between 1807 and 1813 (162). Painted by portrait artist Thomas Baxter (d. 1821), the coolers display classical and historical themes. One cooler depicts the Roman god Jupiter and the mortal combat between Hercules and Hippolyta, Queen of the Amazons; the other illustrates two events from England's history: King Alfred with the neatherd, and Queen Margaret and her son Edward being attacked by a robber.

During the nineteenth century, literature and the visual and theatrical arts reinterpreted history and created narratives by utilizing notions of Romanticism, which focused upon the inevitability of tragedy, loss and death. The works of William Shakespeare were particularly popular at this time, and a number of artists recreated scenes from his plays in their paintings. One such artist was Eugène

Delacroix. His *Lady Macbeth Sleep-Walking* (163) was first exhibited in the Paris Salon of 1850. It recreates *Macbeth,* act five scene one, in which the guilt-ridden woman walks the castle halls following the murder of King Duncan. This painting reveals Delacroix's ability to capture mood through the subtle handling of light and colour.

The nineteenth century also witnessed an increased interest in the lifestyle of the upper class. This interest was reflected by images of outdoor leisure activities and tourist vacation spots. Johan Barthold Jongkind was a Dutch landscape painter and etcher closely affiliated with the French Impressionists. His atmospheric landscapes are said to have influenced the work of Claude Monet, with whom he painted in the late 1850s. He created *Les patineurs, près de Schipluiden* (164) in 1862 by sketching the skaters outdoors and then finishing the work in his studio. It was exhibited along with other Impressionist works in the Salon des Refusés of 1863. Jongkind's work was, for the most part, unappreciated during his lifetime. British artist Alfred Sisley was another Impressionist painter whose work did not receive wide acceptance until after his death. In 1897 he painted *La falaise de Penarth, le soir – temps orageux* (165), which depicts the windswept cliffs at Penarth, Wales, a popular vacation spot.

John Singer Sargent was an American who preferred to live abroad. He was drawn to the aesthetic sensibilities of art and had an elevated sense of style that he felt could only be satisfied in Europe. While Sargent has been proclaimed the greatest portrait painter of his age, he also created a number of landscapes and was interested in the effects of sunlight upon objects. His *San Vigilio, Lake Garda*, 1913 (166) was completed during a painting trip to the Italian Alps.

From the latter part of the nineteenth century to the beginning of the Second World War, a vast array of new artistic styles developed. This modernist art combined artistic themes from the past with innovative techniques. The Italian artist and intellectual Gino Severini combined elements of Picasso's radical cubism and the aesthetics of

traditional classicism in his still-life paintings. His *View from a Balcony*, circa 1930 (167) employs angular planes and surfaces and flattens space within a cityscape reminiscent of Roman wall paintings.

The artistic innovations of French artist Henri Matisse also determined the direction of art in the first half of the twentieth century. His palette of bold primary colours and mastery of sparse, broadly applied lines were revolutionary. Matisse's dramatic use of simple lines to express feeling and tension can be discerned in the ink-and-crayon rendering of *Leda*, 1945 (168). In Roman mythology, Leda was a virtuous woman whom the god Jupiter desired sexually. Capable of assuming any number of forms, Jupiter mated with Leda in the guise of a swan.

The Spanish artist Salvador Dali rejected mainstream art and embraced the beliefs of the Surrealists. His work interpreted Freudian concepts regarding the subconscious, and he injected his ideas into paintings containing historical and religious themes. Perhaps the best-known example of sacred imagery in the collection of the Beaverbrook Art Gallery is Dali's 1957 *Santiago El Grande* (146), which revisits the traditional theme of Christ's Ascension. The painting depicts the apostle Saint James of Compostella, patron saint of Spain, in his role as mediator between the earthly and heavenly realms as he escorts the risen Christ to heaven. Conceived in a dream, this monumental work (measuring 407.7 cm x 304.8 cm) was originally exhibited in the Spanish Pavilion of the 1958 Brussels World's Fair. It has been described as one of Dali's greatest paintings.

The Beaverbrook Art Gallery's International Collection reflects the predominant tastes, lifestyles and world views shared by both artist and patron from the fourteenth to the twentieth century. It affirms the importance of organized religion, social position and didactic narrative within the human experience, and includes examples of the most predominant and popular styles and subjects in Western art during this vast time period. The importance of this collection lies in its diversity

of style, media and subject matter. While the works represent a time and place far removed from North American life today, they afford the viewer a better understanding of Western European culture and the evolution of its artistic practices and production.

ANONYMOUS, German (Cologne) School
Christ on the Cross and Virgin and Child between Two Angels, c.1340
ivory diptych, 12.7 x 20.3 cm
Gift of the Estate of David H.M. Vaughan

ANONYMOUS (active Haarlem and Munster), German School
Virgo inter Virgines, c.1470
oil and tempera on panel, 99.1 x 68.6 cm
Gift of Mrs. A. Murray Vaughan

SANDRO BOTTICELLI (Italian, 1445-1510)
The Resurrection, c.1490
egg tempera on canvas, 132.1 x 106.4 cm
The Beaverbrook Foundation

ANONYMOUS, Italian School
Cassone with Pedestal, sixteenth century
carved and gilt walnut, 63.5 x 175.3 x 57.2 cm
Gift of Mr. and Mrs. John Flemer

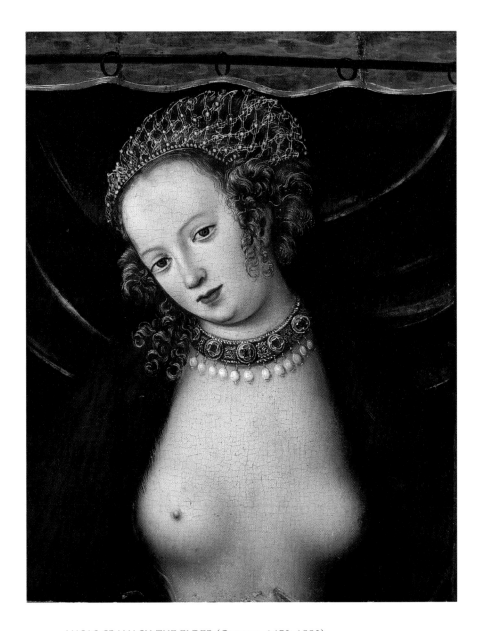

LUCAS CRANACH THE ELDER (German, 1472-1553)
Lucretia, c.1530
oil and tempera on panel, 31.1 x 23.5 cm
Gift of the Estate of David H.M. Vaughan

BARTHOLOMÄUS BRUYN THE ELDER (German, c.1493–1555)
André Reidmor, c.1540
oil and tempera on panel, 57.2 x 44.8 cm
Gift of Mr. and Mrs. John Flemer

CORNEILLE DE LYON (French, c.1510-1574)
Claude de Clermont-Tonnerre, Sieur de Dampierre, c.1540
oil and tempera on panel, 18.1 x 14.8 cm
Gift of Mrs. A. Murray Vaughan

JEAN BAPTISTE MOZIN (after Barend van Orley)
(French, active 1663-1696)
Gobelins tapestry: The Hunts of Maximilian, July (The Report), 1691-93
wool and silk, 401.3 x 497.8 cm
Gift of Mr. and Mrs. John Flemer

BARR, FLIGHT, BARR
Worcester Fruit Coolers (pair), 1807–1813
soft paste porcelain, height: 27.9 cm each
Gift of Mrs. Howard W. Pillow

Facing page:
EUGÈNE DELACROIX (French, 1793–1863)
Lady Macbeth Sleep-Walking, 1850
oil on canvas, 39.4 x 30.5 cm
Gift of Mr. and Mrs. John Flemer

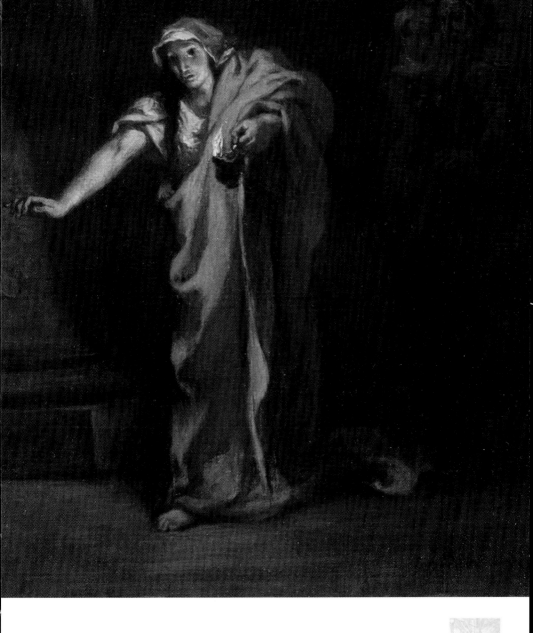

JOHAN BARTHOLD JONGKIND (Dutch, 1819-1891)
Les patineurs, près de Schipluiden, 1862
oil on canvas, 42.5 x 56.5 cm
Bequest of Mr. T.B. Heney

ALFRED SISLEY (British, 1839-1899)
La falaise de Penarth, le soir-temps orageux, 1897
oil on canvas, 55.2 x 66.0 cm
The Beaverbrook Foundation

JOHN SINGER SARGENT (American, 1856-1925)
San Vigilio, Lake Garda, 1913
oil on canvas, 72.1 x 183.8 cm
The Beaverbrook Foundation

GINO SEVERINI (Italian, 1883-1966)
View from a Balcony, c.1930
gouache on paper, 35.9 x 52.7 cm
Gift of the Second Beaverbrook Foundation

HENRI MATISSE (French, 1869-1954)
Leda, 1945
india ink and coloured crayons on paper, 29.2 x 25.7 cm
Gift of David H.M. Vaughan and Lucinda Flemer, executors of the Estate of
the late L. Marguerite Vaughan
© Estate of H. Matisse / SODART 2000

IAN G. LUMSDEN

Ian Lumsden is the dean of Canadian art museum directors having served as the Director of the Beaverbrook Art Gallery since 1969. In his thirty-one years as keeper of the Gallery's collection, it has grown from approximately 750 works to over 3000. He has overseen three major capital projects that have more than doubled the size of the Gallery.

An expert on British art, he has organized exhibitions with accompanying publications including *Bloomsbury Painters and their Circle*, *Gainsborough in Canada* and *Sargent to Freud: Modern British Paintings and Drawings in the Beaverbrook Collection*. In the area of Canadian art, he has published the following titles to accompany exhibitions: *Early Views of British North America*, *Drawings by Carol Hoorn Fraser*, and *Drawings by Jack Weldon Humphrey*.

His expertise extends to the decorative arts in such areas as oriental rugs, silver and glass. He is a member of the Advisory Council of the Canadian Society for the Decorative Arts.

CURTIS JOSEPH COLLINS

Curtis Joseph Collins has been the Head Curator of the Beaverbrook Art Gallery in Fredericton, N.B. since 1997, and is a Ph.D. candidate in the Department of Art History and Communications at McGill University in Montreal. He served as the Director/Curator of the White Water Gallery in North Bay, Ontario, from 1988 to 1990, and was a board member as well as president of Galerie Articule in

Montreal from 1991 to 1995. Over the past fifteen years Collins has curated a variety of touring exhibitions for artist-run centres and public galleries across Canada, and contributed reviews to art magazines including *Parachute, Harbour, Espace,* and *Imposture.* His most recent article "Curating, Context, and Creativity" will be featured in *Thinking Across Culture: Interdisciplinary Practices in Canadian Art* to be published during the fall of 2001 by Galerie Optica and Artexte in Montreal.

LAURIE GLENN

Laurie Glenn is currently Head, Programming and Communications with the Beaverbrook Art Gallery. She holds a Masters Degree in Art History from the University of Victoria, a Bachelor of Education Degree from the University of Alberta and a Bachelor of Arts Degree from Saint Mary's University. She has been employed with numerous art galleries and heritage organizations across the country including Alberta Culture, Edmonton, Alberta; the Prince of Wales Northern Heritage Centre, Yellowknife, N.W.T.; the Manitoba Museum of Man and Nature, Winnipeg, Manitoba; Owens Art Gallery, Sackville, New Brunswick and the Cumberland County Museum in Amherst, Nova Scotia.

She is a feminist art historian with a particular interest in female artistic practice during the early modern period, women's social history, biography and literature.